Advance Praise

"Pam Reid takes readers on a heartfelt journey to growing a brand with visual storytelling. Each chapter is filled with insightful information on how to visually share your company's story and build real human connections with employees and customers. This book is a must-read for those looking to learn how to tell their story with both photography… and love!"
　—**Jason Gandy**, *Owner, Quantum Leap Commerce LLC*

"*Picture Your Profit* is the perfect read for providing guidance and direction on creating brand identity and awareness using visual imagery, even if you don't have a marketing background. In the book, Pam Reid provides insight and many nuggets of wisdom on best practices to avoid pitfalls and mistakes when cultivating your brand. Her examples in the book are so descriptive, it's as if I am in the background watching it unfold as she describes it (that's Pam's brand). After reading Pam Reid's book, I'm definitely changing my approach to taking photographs and I'm recommending this book to my son who loves photography."
　　　　　　　—**Michael Kyle**, *IT Project Manager*

"There were many moments I found myself nodding in agreement with the author's words so vigorously, I lost my place on the page! One of my most favorite phrases the author uses is "get comfortable with being uncomfortable." The challenge of communicating visual storytelling in plain language is not an easy undertaking. Inspirational and positively modern, *Picture Your Profit* illustrates effective photojournalism from Pam Reid's point of view with joyful humor and, most notably, genuine heart. Yes, a business book focused on the expression of love! Learn to love the journey to compelling visual communication with *Picture Your Profit*."

—**Kara Jackson**, *nonprofit communication specialist*

"Picture Your Profit is a compelling and motivational resource that encourages companies to utilize the often neglected tools of love, creativity, passion, transparency, and spontaneity to engage with their employees and customers in the form of visual storytelling. The reader is taken along the author's journey of using strategic imagery that focuses on people in lieu of product, which helped to awaken my own desires to "capture the moment.'"

—**Antalita Raynor**, *CFO, Big Frog of Fayetteville*

"Less is definitely more. *Picture Your Profit* is written in a way that anyone who is a beginner in the story telling field can understand and is captivating enough for a veteran in the field to enjoy and glean from. Pam Reid's approach to engaging in the storytelling endeavor is heartfelt and encompasses the most important and foundational aspect of a good story—the people. I enjoyed every word, every story, and every expression of love this author shared. I wish that everyone who is in a position to make decisions about what is most important when it comes to brand awareness would read this book."

—**Kristin Anderson**, *Marketing and Communications Manager*

"This small and insightful book speaks volumes! It is refreshing to read a business book that doesn't focus only on the business. This book focuses on what matters most, the people and the experiences they have—the experiences that we all share in one way or another, at one time or another. There are a number of things I would not have considered important until reading *Picture Your Profit*. We can learn a lot from this author about how to capture what's most important and how to treat those who are most important. I am inspired to do some things differently where I work and with the people I work with. Actually, I'm going to encourage them to read this book and see what happens."

—**Mike Bowman**, *Human Resources Manager*

"It's a competitive world to be heard, no less seen. Social media makes it easy but the volume of what we are exposed to today is great and overwhelming. *Picture Your Profit* reminds us of how to be aware of the simple things that can ultimately be the greatest things we want to capture and relive over and over again. I've been taking pictures my whole life and it's easy to lose sight of what's important when the competition is so fierce. This book made me think about my "why," and reminded me of the joy I felt at the beginning of my career. I am so appreciative of the timing of this book and the message it conveys. A must-read for any visual storyteller and all my photographer friends."

—**Jeff Light**, *Freelance Photographer*

"*Picture Your Profit* is a well-written, fun read. I love all the sweet stories peppered throughout the book. I also appreciate the good, solid nuggets that I plan to implement in my day-to-day at the company I work for. There is much to glean from this book, and the people I work with can surely benefit from reading it as well. It's important for decision-makers to understand that there is no compromise when it comes to acknowledging and recognizing the value and contributions of those who support your business and your efforts. The good and the not-so-good make for a story that everyone can relate to. There's something to learn from it as well. *Picture Your*

Profit provides an idea, an opportunity if you will, to do something different in the way of elevating the business brand and the people whose backs it all rests on."

—**Tracy Skinner**, *Human Resources Professional*

"I love all the information, stories, and pics in this phenomenal book. I learned so much that I plan to incorporate as I continue to create my design stories. *Picture your Profit* is a very informative read. Pam Reid shares with the audience another side of photography. She is compelled to create and deliver something special in each experience. Culminated with the knowledge of her profession, the way she crafts her stories tells you she is passionate and loves every detail. I'm excited to watch her in her element, as she creates through her lens, not just ordinary as she puts it, but "extraordinary" photo stories that all can enjoy!"

—**Alicia Taylor**, *owner and interior designer, Design and Style Studio*

"What a fantastic read! Pam Reid is very talented. This was such a fantastic quote: "love is the most powerful emotion there is. If you can harness the power of love, simply by genuinely expressing it to others, the most amazing things begin to happen." This is spot on! Things that have love behind them are set apart. They have a different "something" about them. I also connected to

when the author said that customers have a need. When you demonstrate an understanding of this, it can help to motivate them. This is so relevant to teaching! Students are our customers and we need them to trust that we understand them and their needs so that we can help motivate them to succeed! This book can totally connect to and be relevant for people in many different fields."

—**Nicole Mosley** *Brown, Educator*

Picture Your Profit

How a VISUAL Story Can
ELEVATE a Brand and a Team

PAM REID

NEW YORK

LONDON • NASHVILLE • MELBOURNE • VANCOUVER

Picture Your Profit
How a Visual Story Can Elevate a Brand and a Team

© 2021 Pam Reid

All rights reserved. No portion of this book may be reproduced, stored in a retrieval system, or transmitted in any form or by any means—electronic, mechanical, photocopy, recording, scanning, or other—except for brief quotations in critical reviews or articles, without the prior written permission of the publisher.

Published in New York, New York, by Morgan James Publishing in partnership with Difference Press. Morgan James is a trademark of Morgan James, LLC.
www.MorganJamesPublishing.com

ISBN 9781631950377 paperback
ISBN 9781631950384 eBook
ISBN 9781631952098 audio
Library of Congress Control Number: 2020932312

Cover Design: Christopher Kirk www.GFSstudio.com

Interior Design: Chris Treccani www.3dogcreative.net

Editor: Moriah Howell

Book Coaching: The Author Incubator

Morgan James is a proud partner of Habitat for Humanity Peninsula and Greater Williamsburg. Partners in building since 2006.

Get involved today! Visit
MorganJamesPublishing.com/giving-back

This book is dedicated to my first true love, my childhood sweetheart and husband, Craig Alexander Reid. Thank you for always supporting me in everything I do. I love you.

Service and the significance you bring to your service is that which is lasting.
—**Oprah Winfrey**

Table of Contents

Foreword		*xv*
Backdrop		*xx*
Chapter 1:	Candid Camera	1
Chapter 2:	Properly Exposed	7
Chapter 3:	Well-Captured	21
Principles		**34**
Chapter 4:	Less Is More	35
Chapter 5:	Content Is Critical	43
Chapter 6:	People Make Perfect	61
Chapter 7:	Build Your Brand	71
Chapter 8:	Conflict Is Compelling	83
Chapter 9:	Ordinary to Extraordinary	89
Chapter 10:	Intentionality Is Integral	97
Chapter 11:	Movement Is Meaningful	105

Camera Ready		**110**
Chapter 12:	Snapshot	111
Chapter 13:	Picture Your Profit	119

Acknowledgments — *129*
Thank You — *133*
About the Author — *135*

Foreword

Picture this—a middle-aged white man wearing a pink tutu and a blue wig running a half-marathon with a middle-aged African American woman also wearing a tutu. The two people were from totally different backgrounds, yet very similar in world-view and outlook. The man was a local business leader, a former Board Chair of the Chamber of Commerce. The woman was an Executive Director of a local non-profit. So begins the true story of how I really got to know Pam Reid.

As you will learn in Pam's new book, all good stories begin with an opportunity. The opportunity of our meeting was the occasion of the Diva Half-marathon—Pam's first 13.1 mile running event. I had done countless endurance events and had agreed to run as an honorary member of the Fayette Woman Magazine running team. My wife was a part

of the team and encouraged me to come along—and so I did and dressed the part too!

During the race, I had the opportunity to encourage other runners including Pam Reid. As the event progressed I really got to know Pam as we talked about family, business, her faith, and our shared sense of community. We also talked about branding and marketing. I own a digital marketing firm and often collaborate with other local professionals like Pam. It's truly an honor to have been asked to contribute to Pam's new book by writing this foreword.

In this book, you will learn Pam's distilled wisdom on how to effectively communicate a brand through visual story telling. No Opportunity Wasted (NOW) is one of her keys to being aware of what's going on. Awareness positions one to capture opportunities to establish a realistic, captivating story.

As the book progresses, Pam shares time-tested principles and techniques for establishing authority in the marketplace, while being true to the brand story. One of the things that makes Pam's message so unique is her honesty in which she encourages the reader to include all the parts of the story—the good and the not-so-good.

Sometimes the not-so-good may involve adversity or conflict. Pam is realistic enough to

know that this also helps make for a compelling visual narrative. Pam tells us that the best stories tend to be those that accurately record the conflict and subsequent resolution. All too often marketers only communicate the unblemished good—but that is not life. Life is all about dealing with challenges and Pam embodies that spirit personally and in her photos and writing.

Pam is a people person and she correctly points out that the foundation of visual story telling involves people. Getting others to care about the people in a story is what makes a good story a great one. This is true of all timeless stories and Pam helps drive that message home in her book. Following her advice will help elevate your visual story telling from ordinary to extraordinary.

While it's important to focus on the elements of the story and the business of storytelling, Pam rightly encourages the reader to focus on the fun—just as she and I did years ago at the half-marathon. I know that you'll enjoy the journey with Pam as you read the book and learn how to profit from your work as a visual storyteller.

I think it's only appropriate to end this foreword with a picture to go along with the story.

xviii | *Picture Your Profit*

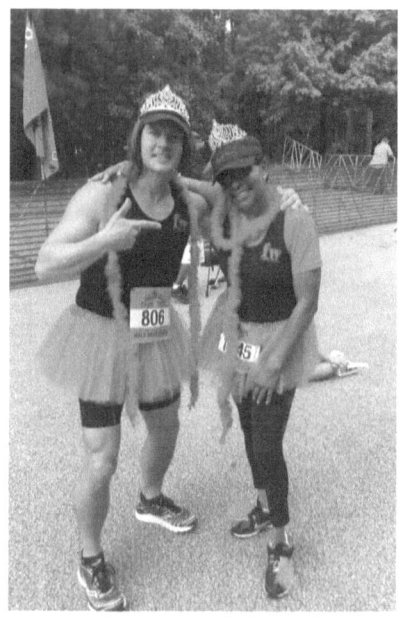

"Diva Joe" Domaleski with the book's author Pam Reid at the Diva Half-Marathon finish line—Pam's first half-marathon finish!

"Diva Joe" Domaleski
Owner/CEO, Country Fried Creative

Backdrop

Chapter 1:

Candid Camera

―●―

Photography for me is not looking, it's feeling. If you can't feel what you're looking at, then you're never going to get others to feel anything when they look at your pictures.
—Don McCullin

With attention spans the way they are today, anything that does not immediately catch a person's attention will most likely be scrolled right over. There is so much scrolling today that people will only stop for something that catches their eye. Holding a person's attention is a whole other thing indeed. Some say that today, with the right strategy, it can be easy to get someone's attention *and* just as easy to lose it. According to

a study done by Microsoft, the rising popularity of smartphones, mobile data, messaging apps, and social media is the cause behind falling attention rates. The information age has changed the general attention span. A recently published study from researchers at the Technical University of Denmark suggests the collective global attention span is narrowing due to the volume of information that is presented to the public. The study shows people now have more things to focus on, and because of this, people focus on things for shorter periods … but you know this already, and probably experience it for yourself. You and I are, of course, among the "people."

We the people are also among the distracted … now more than ever. Today, employees arrive to work already fully-loaded with a host of challenges and concerns in their heads. Family, health, finances, relationships, and a lack of motivation contribute significantly to an employee's engagement and productivity levels. It's hard to tell a good visual story when those who would create the story, and ultimately carry and embody the premise of the story, are "under the weather." It's no wonder that in many companies, both production and morale are at an all-time low, and turnover rates are at an all-time high.

Perhaps it was not long ago - before you saw the job description that caught your eye and got you feeling a new sense of excitement - that you were feeling similar to the way many people feel today. Responsibilities, deadlines, and the challenges of life can be quite a bit to manage; then add countless amounts of information, content, and access to pretty much everything to the mix, and there you have it … the makings of being easily distracted and overwhelmed.

How does anyone stay focused on their goals and meet their deadlines with so much coming at them? How do people run their businesses and serve their clients … with excellence, no less? How do you immerse yourself in your projects and manage all that you are responsible for? How do companies keep their employees encouraged and engaged while working to retain relevancy and profitability in their market? Even as I type and respond to messages, ads are popping up in my peripheral, vying for my attention.

You are tasked with a new challenge: to visually tell your company's story with the use of photography. You are aware of the challenges that exist with the staff, and you're hoping that these challenges won't create obstacles to getting the project done. Getting the project done is not as much of an issue

as is getting "buy-in" and getting the project done exceedingly well. This will be the first time anyone has attempted to tell your company's story … visually, that is. This is most certainly the first time anyone has set out to include a strategy to engage and elevate the staff—the employees, the team—while elevating the company's brand. It's exciting because it's a new opportunity for you. You have enough skill set to build upon, but you're not quite sure where to begin.

A friend of mine shared an acronym with me that I'd like to share with you: N.O.W. It stands for "No Opportunities Wasted." I'm sharing it so you can be reminded of it when you encounter the dynamics you will have to overcome with this project. Opportunities will present themselves, and you will want to be open, discerning, and ready to take advantage of the ones that are meant for your company *and* your team. Your company wants its story told and told well. We both know it's all about attracting clients and increasing the company's bottom line, but what you may not know is that the story is equally about the team and the degree to which it has an impact on both the team and the bottom line.

I want to congratulate you on this new opportunity. Ten years ago, maybe even five years

ago, if someone told you that you would be using photography to do visual storytelling for your company, what would you have said to them? Adding visual storytelling to your company's marketing strategy is the most effective way today to leverage compelling narratives and to place your customers at the heart of the story. When you add the right amount and type of visual appeal, you can empower customers and drive business. While you want to wow your audience and move them into action, there's much to be said about telling a story that lets your audience know who you are as a company—who you really are—the human, personal side.

If you are new to your role in media, marketing, and/or communications, telling your company's story using photography is one of several ways to add a visual component to how your audience sees you. If you want to create impact, interest, and momentum, take photos that captivate, and that people would love to share with others. That's not so easy to do if you are not clear on the message you want to convey with your photos. It's also not so easy even when you *are* clear on your message, but you remain unsure about what exactly to capture, or you're not able to recognize when the perfect opportunity or shot presents itself. It's also not so easy when you have a deadline to meet, and you find

yourself at the helm of a disengaged team. You could go it alone, but ideally, you would have a team; a diverse resource of professionals to collaborate and to work side-by-side with.

Just like you and me, audiences want to be informed, inspired, and engaged. Visual storytelling is a powerful way to connect deeper with online audiences across devices. It can also help to take what might be considered some of the more complex aspects of your company's business and make them easier for audiences to understand and absorb, thereby delivering more impact as a result. Consider this role you're in as the greatest opportunity to tell the story that can build distinction, authority, and trustworthiness for your company's brand. It's also the ideal time to consider taking a pulse on your team's engagement level. Whether you realize it or not, you need them on many levels. It's not just about the marketing, media, and communications professionals. It's about the people who represent the company—the ones who provide the services and sell the products to your clients. The ones who represent the company and will contribute to the client's experience—good or bad. I hope you consider this book as the right place to start your visual storytelling journey.

Chapter 2:

Properly Exposed

When people ask me what equipment I use—
I tell them my eyes.
—ANONYMOUS

It's never easy to be the "new kid"; at least, I don't believe it is for most. There's the matter of learning and navigating the culture you've just landed in, and the harder part—becoming acquainted with and developing relationships with its inhabitants. I worked in a culture where when you were hired, there was an understanding and confidence that not only did you have the knowledge and expertise to do the job you were hired to do, but that you would do that job exceedingly well. Depending on your position in the organization, you were assigned an

office and a mentor and then sent on your merry way to perform, produce, and blow the competition away. Now and then a used copy of a favorite business book was tossed your way, and if you were fortunate enough to be considered approachable and likable, you received plenty of invitations for lunch. Proving myself in a culture that hired from the pool of "you should already know how" candidates was a little stressful and challenging to navigate, to say the least. I had to quickly assimilate, make meaningful connections, and figure out the most pressing needs from the list of duties I was responsible for … all on my own; and the sooner I got started, the better.

I mentioned that I've been taking pictures for a long time, and I have, since the age of thirteen. I got my first Polaroid camera as a birthday present and took pictures non-stop. I would vigorously fan the 4 x 3.5 piece of film and look intermittently as an image slowly and magically revealed itself, right before my eyes. I went through countless boxes of Polaroid film each week. When I look back and remember how my bedroom trash can was always full of empty film boxes, I believe my parents must have spent a small fortune on film alone. I imagine that today, with my journey and success as a photographer, they don't have any regrets. As a child, teen, and into early adulthood, I always had

an affinity towards capturing special moments and candid photos of people. I never asked anyone to pose. The idea of asking a person or group to pose and "say cheese" to take a picture just seemed so incredibly fake and staged to me. I had other ideas entirely … my family didn't like it though. They preferred to have control over how they looked in photos. They preferred to be posed. When I showed them candid photos of themselves, they would say with a great deal of disappointment, "I'm not looking! Why didn't you tell me you were taking a picture of me? I would have posed for you." It seemed they just didn't get it. It must have been the *times*, but then again, taking pictures with a Polaroid did not make me a photographer. And there's nothing wrong with staging a photo. As you well know, we photographers *make* photos.

I was the envy of my friends. My parents kept up with making sure I had the latest camera, seeing as how I enjoyed taking pictures so much. I received my first and only disc camera when I left for the military after graduation. People were impressed with the round, flat disc that held 15 exposures. This was great considering the Polaroid film box contained only ten pieces. The quality of the photos, however, was far less superior to that of the Polaroid. Actually, they were pretty crappy and so the disc

camera was soon discontinued. Then I moved on to my first 35mm camera—a Canon. I can't help but smile when I think of the 35mm chapters of my photo journey. I would make my weekly trips to the shop to get my film developed. I had a stash of film developing envelopes and I would *always* order "doubles." I had to. I just knew someone would want a copy of the picture of themselves, and I never wanted to give up my only copy.

To this day, I have countless boxes of photos in storage. They make for absolutely wonderful trips down memory lane. I took so many pictures and developed so much film, that the employees in the Kodak Photo Centers would call me to tell me how much they loved my photos. They also called me when they would not be able to develop the inappropriate ones. Ha! It was against company policy. Don't judge. I was young. After graduating to using a top of the line 35mm camera, I took the leap to digital. No purchasing film? You mean I can take the photo as many times as I need to until I am completely satisfied? Megapixels? The evolution of photography, along with the tools and technology, are nothing short of amazing to this veteran. Today, I never leave home without my DSLR.

I've been a photographer for the past fifteen years. I've been blessed to tell stories with photos,

and, according to clients, I tell them well. When you tell someone's story with photos, whether it be their milestone birthday story, their retirement story, their "leap of faith" story, their business launch story, or their anniversary story, it's a special thing to find yourself included in a way that matters. I'm not just contracted to tell these stories, I'm contracted to be there from beginning to end to capture not just the images, but the feelings and emotions that go along with the event—the introduction, the substantive parts in the middle, and the ending, in a meaningful and memorable way. By the time the story is captured and retold, nothing has been left out. The customer not only gets to experience the event over and over again, but they also get to experience it in an all-inclusive kind of way. They get to see and experience the moments that they didn't participate in themselves. They get to be surprised by seeing the wonderful experiences had by their guests. They get to see and feel over and over again, the love, the heart, the soul, the fun, the excitement, the joy, the laughter, and everything else that took place during the moments that make up that memorable event. That's my craft. That's one of the many gifts God has blessed me with. Some say I have an "eye." I say everyone has an eye … you'd be surprised by what

some intentional thought, some training, and a little inspiration can do for developing an "eye."

I had many occasions during my time in the military and corporate America to be in front of a camera. It was usually to record a message of support for the local community and its charities, or a message to some smaller group about service excellence, along with a plug about our company's products and services. Sometimes I would be in front of a camera to offer and express a sentiment of gratitude for some level of engagement or expression of support received from an individual or group. There were the marketing videos too … oh, man, there were the marketing videos. I would just stand or sit in front of a camera talking, and talking, and talking.

I can remember the day that I recorded what would end up being the last video I would make for one of my larger employers. Like most days, my suit choice was spot on. It was a good hair day, my skin shown bright, and my smile would not let me down. The "experts" did a sound check then asked me to "move a little to the left" and then "move a little more to the right," like I was a piece of furniture in a new house. Once I was standing in position, the next task was to adjust the lighting. Sometimes no one was concerned about lighting at all. Yes. This

was some years ago; a very scary time indeed. Then it was showtime. I was given the universal hand signal to alert me that we were about to get started. The man behind the camera would point his finger toward me just before he was to press the record button. That was the signal for me to start talking.

Nothing was exciting about me standing in front of the camera and talking. Yes, it's true that attention spans were a little longer back then, but I imagine that audiences still wanted to be engaged and impressed by what they were spending their time watching. I remember that at the end of that particular recording, I felt like something was missing. I wasn't sure what exactly, but I was pretty certain we could have been a little more creative in making that marketing video. When all was said and done, the video was edited and we came together as a team to watch the final product. There were a total of seven of us business professionals talking one after the other, explaining what it is we did, and how well we believed we did it. Yes, we all looked the part and said all the "right" words, but it was nothing short of boring and *forgettable*.

Back then, the focus was always on the existing clients and the potential ones. I never gave thought to the employees of the company as related directly to the company's brand. This especially should

have included the marketing team, professionals who worked hard to not only convey a compelling message to our target audience but also to keep their jobs. I didn't think about the plans, the processes, and the pitfalls of these individuals who carried the weight of telling the company's story (when "storytelling" wasn't even a thing). Were these individuals in the right jobs? If so, were they happy and engaged? Were they supported in their efforts to be creative in their roles? Did they have the talent to do what was required of them? Did they have the creative vision to keep our company competitive? Who knows … I didn't think about them or any of this in the beginning, but as the world of media and marketing changed, so did my perspective … and my heart.

Things progressed through the years, and the corporate giant I worked for hired the best marketing professionals money could buy. The change started with professional-looking photos and images as well as flash animation. All in all, the company's marketing began to look cutting edge and more like the money we were charging and generating from serving our clients, but something was still missing. And I still wasn't quite sure what it was. But as I continued to cultivate strong relationships with my staff, the partnership, and our clients, I found myself

sharing words that didn't quite sound like what you would expect from a financial services company, and definitely not from accountants and actuaries.

I also found myself bringing "props" with me to meetings. These items became part of the narrative and were conversation pieces that opened doors for extended conversations and meetings with clients. They were quite simply photos I had taken during company events, employee trainings, and client meetings—photos that told the story that existed behind the scenes, behind the numbers, behind the data and analysis reports. These stories came naturally as I was pretty much immersed in the day-to-day of everything. How simple were these photos? Not simple at all. They became the most meaningful tools we would come to use to increase awareness about who we were as a company.

And who were we? Well, as you continue to read through this book, the answer to that question will unfold in a way that will enable you to see clearly for yourself what your own company's story is and where it lies.

I believe it's safe and fair to say that a professional is someone who hones their craft in a consistent and disciplined way. Professionals don't stop doing what they do. They are always learning, perfecting, staying on top of what's going on in their industry,

and staying ahead of their competition. To rise above the challenges that frequently come into play during our journey to success and being able to stay calm and composed is a discipline worth practicing. We need to persevere and persist, even when we grow weary and feel like giving up. I hope you have a good level of self-discipline. If you don't, practicing self-discipline is going to be necessary to rise above the challenges that will inevitably come, as you work to elevate your brand and your team through photography and your storytelling goals. When you master self-discipline, the benefits extend beyond the workplace. You will find that you can accomplish your goals in every area of your life. Knowing yourself and being honest with *you*, is a must when it comes to mastering self-discipline and becoming self-motivated.

That said, I am truly grateful for the woman God created me to be. I want to emphasize the point of self-discipline and self-motivation because when we get into what's necessary to blow your competition out the water, it's having these characteristics that will make all the difference for you. Sometimes you'll take hundreds if not thousands of photos for just one project. If you don't have the discipline and if you can't remain consistent in your efforts towards mastery, you can bet you won't be able to create that

brand, that image, or tell that story which could be the difference between getting paid and getting canned.

I guess you can say that I got a break … someone saw something in me. They saw my work ethic, my hard work, and my willingness to learn. I was, and still am, super coachable. I was hired into a leadership position. I was thrilled when the opportunity presented itself for me to make a name for myself in an area where I had passion and skill. I wasn't sure how or where to begin, but I certainly knew what skills I possessed and how to leverage them. I reshaped my role in the company, added value in a way that became much sought after, and a model for others to follow. My ability to tell stories with photos overflowed and became a part of both my professional and personal life. I have happy clients and I look forward to every encounter. Every experience, every event, every encounter is unique, meaningful, and memorable … for real. There are shots that you just know your client is going to love and want to have enlarged to display somewhere in their home or office. You know it and you feel it. I believe that what others see in me has everything to do with my heart. When I say I love photos, it's not just the photos I take. I can easily find myself looking at someone else's photo albums for hours. I

love looking at the images and getting a feel for their rich past, and the experiences that shaped them. I love seeing old photos of people and revel in what they look like today … sometimes it's funny indeed.

I would be remiss if I left Bob out of this chapter because Bob saw something in me. I met him at a holiday party. I wasn't contracted to take photos at this particular event. I was a guest, and as I've already mentioned, I never leave home without my camera. I took a good number of photos that evening for my enjoyment. I was very careful to respect that fact that there was a photographer who had been hired to take photos that night. It was also clear to me that the photographer was not a photojournalist. He didn't take any photos of the things I wished he had. I cringed when I saw him just standing and enjoying aspects of the event that he should have been photographing, but then again, he wasn't telling the story of the event, and I imagine the client didn't know that photo journaling her event was an option available to her. The night progressed on, and towards the end, Bob introduced himself with a question: "Are you a photographer?" To which I responded, "Yes. I tell stories with photos." We continued to talk and I learned that Bob's specialty was portrait and wedding photography and that he had been shooting weddings for close to thirty years. I also

learned that Bob was the client's neighbor and that was how he came to be hired as the photographer for the evening. I so wished I could have shown Bob's client what she was missing in the way of a final product, but it would not have been appropriate.

I enjoyed my talk with Bob and very much appreciated when he offered to mentor and teach me aspects of the industry he had gleaned throughout his career. When I met Bob, I was only a few years into having started my professional photo journaling business. There was still much for me to learn, and Bob was genuinely willing to share. He appreciated my desire to learn and how attentive to detail I was. Bob taught me some valuable lessons and tricks that would eventually save me hours of time and frustration. I miss Bob, he moved across the country after the loss of one of his loved ones. Before Bob left for the West Coast, he told me I was going to make a positive impact in the lives of others. When I asked how he knew this, he said, "You *love*, and you have the courage to express it. The love will show through your work." Isn't that a beautiful sentiment? It makes my heart swell when I think of Bob and his sweet words. Suffice it to say, I've been where you are, and like Bob, I'm looking forward to sharing with you what I know; at least enough to lay a foundation to get you on your way to telling your

story, your company's story, through photography. Who knows … perhaps you'll be able to positively impact the members of your team along the way.

Chapter 3:

Well-Captured

A thing that you see in my pictures is that I was not afraid to fall in love with these people.
—ANNIE LEIBOVITZ

I recall the day I received multiple phone calls regarding a photo I posted on social media. It was an incredible experience and certainly a surprise to receive requests to not only have access to the original file but requests to use the photo as well. These requests came from local newspapers, magazines, and my local Chamber of Commerce. Allow me to tell you how perfectly aligned everything was the moment "the shot" showed itself. It was an early morning shot. The sun had newly risen and the dew was still on the grass. The sun allowed the

images in the photo to cast a shadow that I will not forget. The subjects were moving. The photo, once captured, would have a great deal of expression, as well as a very powerful message. The photo would evoke pride and hope in the future. I was walking behind the subjects and looking down while digging in my camera bag, and when I looked up, there it was—the perfect shot—of course I took it. I had my camera around my neck, as usual. The words I posted along with the photo weren't necessary. I could have, and probably should have, posted the photo without words so I could read the multitude of diverse comments and perspectives on what the photo revealed to each individual. In any event, the photo was incredibly well-received and ended up being published in a variety of periodicals. Well, that was the first, and fortunately not the last time that a good level of interest would be generated as a result of one of my photos.

As the next chapters unfold, we will explore the principles I use for visual storytelling. While there are many mediums professionals use today to visually tell a story, the focus for this book is on using photography to that end. The focus is also on helping you to tell the story that will show your employer and your company's clients how effective you are in your role within the company. I'll make

suggestions on when and how to engage other professionals with diverse skill sets, as well as how to keep the members of your team, if you are leading one, focused, engaged, and organized. I can hardly wait to share the added benefits this will create for your company. We'll talk about tools and resources as well. You'll also learn how to determine when a story is going in the wrong direction or going nowhere fast. We'll discuss common mistakes and I'll share the mistakes I've made that could have easily caused me to reconsider my line of work. The bottom line is, this book is designed to be a resource you'll reference throughout your photo and team-building journey.

Before we dive in, I want to talk about the basics of storytelling. To benefit from a story told well, first, all the aspects of the story must be known and available to use. Whether you use them all or not, all the parts of the story must be known and available to you, and here's why: every part of the story matters because, quite simply, a story *unfolds*. One part builds on the last part. You can't have part three or part five without there having been a part two or a part four. Well, you can, but there will be a disconnect; and when you tell the story, some disconnects will be more obvious than others. All of the parts—the good and the not so good, the engaging and the not so engaging—are

equally important. Once you have the entire story, you can then decide how best to tell it, depending on the objective you want to achieve by telling it.

There are certain things in life that we'd *love* to avoid. But what we don't often recognize is that even the things we'd prefer not to experience or share, play a significant role in our story, in our growth, and our development. These experiences can even play an instrumental role in the lives of others. How we respond to and/or how we overcome some of life's less pleasant things, can benefit others who may be going through something similar. Have you ever seen the movie, *Click*? The dad, played by Adam Sandler, seems to have it all, but his wife, played by Kate Beckinsale, is increasingly frustrated by the amount of time he has to spend at work. The dad cannot find time to be at home until he meets an eccentric inventor who gives him a universal remote that controls time.

At first, all seems well as dad happily presses the "fast forward" button and skips the boring times of his life, as well as the times he just doesn't want to make time for; including meals at the dinner table, times of sickness, and intimacy with his wife even. As he continues to press the fast forward button, what he doesn't realize is that he is fast-forwarding through all the good stuff as well. You

see, he missed all the opportunities for others to express love to him while he was sick. He missed all the meaningful dinner conversations where he would have heard about the ups and downs, and all the wonderful accomplishments and milestones of his children's lives. He missed the opportunity to participate and weigh-in on the topics that would have the most influence on his children's lives. By pressing that "fast forward" button during intimacy with his wife, he contributed to her feelings of being completely disconnected from him… physically and emotionally. The dad doesn't recognize that the remote begins to take over his life by memorizing all the types of things he'd rather not experience, so when he got sick or had to engage in anything that would keep him from working, the remote automatically fast-forwarded Adam's character right through the event.

By the end of the movie, it would seem that he lost pretty much everything, including his family; and he does, but fortunately, he learns to cherish *every* precious moment he has remaining with his family.

Why am I sharing this with you? The movie has such a powerful message. In the mundane and inconvenient, in the challenges and stress, in the pain and discomfort, there is love. There is a story—a great story. Absolutely there is. James 1:2-4

says, "Consider it pure joy, my brothers and sisters, whenever you face trials of many kinds, because you know that the testing of your faith produces perseverance. Let perseverance finish its work so that you may be mature and complete, not lacking anything." I love this scripture. It comes to mind every time I'm faced with something difficult; every time I'm uncomfortable. It reminds me that all that we go through, and I do mean *all* that we go through, is meant to grow us, develop us, and prepare us for the next big thing.

Being able to tell your company's story would certainly qualify as a "next big thing", especially if you don't know exactly where and/or how to begin. I believe a wedding would qualify as a "next big thing" as well. When I was requested to be the photographer at my first wedding job, I couldn't help but think, "Ah, I get to tell the ultimate love story." I needed to know everything. I met with the client in advance of us signing any contract, to get the story of how they came to be as a couple. The future Mr. & Mrs. were happy to oblige. I got to hear about how they met; some funny and sweet stories about their early dates, their break-ups and make-ups, and their hopes and dreams. It was sublime, and I felt honored to be a part of their special day.

I made it to one of the dress shopping appointments, an appointment with the venue and caterer, and even spent time with both the maid of honor and best man. Oh, I don't want to forget the rehearsal dinner. Of course, I always stayed in the background—which is important for a photojournalist to do—and by the time the couple's special day arrived, I had been so immersed in the unfolding of their wedding story, I felt and was treated like family.

Needless to say, I exceeded the expectations of the new Mr. & Mrs. They both laughed and cried as I sat with them after their honeymoon and shared their wedding story through some pretty amazing photos. I had learned some pretty cool things from my wedding photographer friend, Bob, but I took the experience to a whole other level. Think about what it could mean for you when you strategize about telling your company's story. Consider what you may need to do to have access and to experience all you need to, to tell the story in a meaningful, impactful and memorable way. Of course, there is a vast difference between a wedding story and a company's brand story, but so much of the effort and all you need to consider is essential for both. What are the differences? Well, for one, you don't need to do a competitive assessment for a wedding,

and you are certainly not concerning yourself with a brand, or customers in a marketplace.

What I'd like you to glean from this specific experience is that there is a benefit to truly immersing yourself in your visual story project, and to connect with "the characters" in an intimate and meaningful way. I would like for you to understand that there is quite a bit of pre-work involved in preparing to tell a complete and impactful story. I'm also hoping that it resonates with you, the fact that you can create a story that can move an audience to become emotionally charged and inspired to act. The relevance here is that all the details and how *you* show up matter a great deal. There's more, especially if you have a team to lead and collaborate with, but I'll be sure to touch on that as we move along.

If you haven't been attending company events… start! You can't possibly capture moments if you're not there when they happen. This is where and how you can begin collecting and building a resource of photos. They ultimately may not be used in your story sequence, but they will remind you of some very important story elements. Like I mentioned earlier, you need all the parts.

If you have young children, you may not yet be aware that each year, parents spend *thousands* of dollars on just one student's senior photos. As you

might guess, this is not an aspect of photography that I enjoy; at least, I thought I didn't. When my daughter became a senior in high school, she needed photos and I was not going to pay for any. There were photos for the yearbook, the graduation announcement, and the celebration party that I had to consider.

I gave quite a bit of thought to what I was going to do to make her senior photos stand out, and also about how to ensure the experience would be enjoyable. I mean, I don't know many teens who get excited about their parents taking their photos, especially when their friends are getting theirs done at professional studios. I settled on taking outdoor shots and having my daughter simply move about to experience and enjoy the beautiful setting I chose for the shoot. After about a half-hour, it seemed like the soon-to-be-graduate had all but forgotten I was there. She moved about slowly, touching flowers and plants as she passed. The expressions on her face changed as quickly as the thoughts that generated them. I spoke and that snapped her back. I was surprised when she looked up at me and smiled. We didn't feel the need to go to another location. I felt like I got some great shots that she would be proud of, and she was ready to go and catch up with her friends. I loaded the images onto my computer and I am happy to share that my first-born was more

than pleased. It was hard to choose her favorites, but she finally settled on the ones I secretly liked the most as well. I placed an order for one of the images to be printed on a giant poster board to use as part of the decoration for her graduation party. When I went to pick up the poster, it was even larger than I imagined it would be, and it was on display in front of the store. I gave my name and in addition to my order, the employee handed me the names and phone numbers of three different parents who wanted to be contacted about having photos taken of their students.

There's the value in a story told well.

The story you tell will and should have more than one use. If told well, your story will build, expand, and strengthen your company's brand. It will be a marketing piece that will instill pride in the people who work for the company; especially the team that played a part in its creation. The visual narrative will be created in such a way that while the "hero" gets a resolution to their problem, like a good book, you are sorry to see it end.

As my business grows with each well-captured story, so does my ability to positively impact the lives of others. This journey is not only about contracts and currency. It's about adding beauty to the lives of others. It's about expressing love to them. As your

ability to tell a well-captured story increases and your motivation is to serve and love others, you will be amazed at what will unfold for you.

At this point, especially if you are a corporate business professional, you may be wondering what all this love and heart stuff are about; why you would even care to add beauty to the lives of others. Well, here's why—love is the most powerful emotion there is. If you can harness the power of love, simply by genuinely expressing it to others, the most amazing things begin to happen. Let me tell you about photographing an Instagram Influencer: when the opportunity to photograph an Instagram Influencer presented itself, I was over-the-top excited. This Influencer is an interior designer. Who would be more excited to tell a "before and after" story than an interior designer? Ok, yes, you're right … a person who has lost a considerable amount of weight would be … but for now, let's stay with my interior designer client. Man! It was an incredible experience. I learned a great deal during that shoot, and I left the designer incredibly pleased and happy. She said she knew and could feel the love and desire I had for her, and her campaign with a multi-million dollar company, to be over-the-top successful. There was quite a bit at play for that shoot—makeup artist, detail person, cleaning person, the designer, and yours truly. To

this day, the designer uses my photos for her profile and campaign submissions. I look at the design story we told for that particular campaign, and it is most definitely a story that expresses love for the special spaces in one's home, and details the loving touches that are pleasing to the eye that make your house a welcoming home and personal sanctuary. There's the love. It matters. If you're trying to tell your company's story and expand its brand without love and passion, it's going to take a heck of a lot more work than it should. Plus, your campaign will miss out on some pretty amazing power. I made new friends the day I did the designer shoot. I always do. That should be a goal as well. People enter our lives for a reason and a season. You'll see how it's all part of the bigger picture … pun intended.

The last thing I'll share before we dive into the principles, which I believe will have you well on your way to visual storytelling with photos, is that I love you. Yes I do, and I hope that you're not surprised. I believe that to do anything to one's fullest it has to be motivated by love. For this purpose, this book, the expression of love begins with me. I love you enough to want to share and to spend the time doing so. Love has been and continues to be expressed to me every day. Of course, I have a responsibility to pay it forward. I've come to realize that the more love I

express, the more love I feel, and the more I prefer to have it this way. The more love I express, the richer the stories are. The richer the stories are, the richer the relationships become, and in turn, the more that love is welcome. It's a beautiful cycle and everything else seems to just come. God is the Master Orchestrator and He continues to place the most amazing people and opportunities along my life's journey.

I'm so glad you're here. Each of the principles outlined in the upcoming chapters will build one upon the other. They will unfold in such a way that will allow you to easily put them into practice while the project is underway. You should even go as far as to share the principles with your team so that each principle is accounted for, thereby establishing ownership for making sure each principle gets factored into the process. I suggest you read and absorb them first, then establish a strategy for how best to involve your team. I'd like to also suggest that you take a collaborative approach by simply asking them. Including them on the front-end can help individual and team engagement skyrocket. Ready? Let's dive in.

Principles

Chapter 4:

Less Is More

I don't trust words. I trust pictures.
—GILLES PERESS

Only God knew that when Ludwig Mies van der Rohe adopted the phrase "less is more" in 1947, it would become one of my favorite quotes at home and in business. I always tell my kids that less is more. I used it quite a bit during their early teen years when the use of perfume and cologne seemed more popular than the use of soap and deodorant. When it comes to visual storytelling, a minimalist approach to the use of words is much more effective. And just to share a bit of trivia, Mies van der Rohe was not actually the originator of the

phrase. It was such, however, that the phrase became inextricably linked to him.

How do you suggest that less is more when people love to talk? Shoot, *I* love to talk. I remember when during a Bible study lesson, I happened upon this scripture in Proverbs 10:19: "When words are many, sin is unavoidable, but he who restrains his lips is wise." I love the Good News Translation: "The more you talk, the more likely you are to sin. If you are wise, you will keep quiet." How about the New Living Translation version? "Too much talk leads to sin. Be sensible and keep your mouth shut." Well, can the message become any clearer than that? Less is certainly more, and the same holds true for visual storytelling.

Today, the battle for customer attention continues and is more competitive than ever. Technology has made the ability to create stunning visual content easier and quicker to produce. The pressure to deliver meaningful, impactful, and memorable content is compounded by our always-on digital, social, and mobile world. I can tell you first-hand that images have made all the difference in my content marketing approach. Images are incredibly powerful in helping to capture your audience's attention, and to reach deeper into their hearts and minds. There's such an overload of information today that it's no

wonder people have such short attention spans and are overly distracted. As we use this book to focus on the impact visual storytelling can have on brands and individuals alike, let's remain open to the fact that the more authentic and genuine you are to your craft, the more likely you are to capture and keep your audience's attention. When your story can evoke emotion, tantalize the senses, demonstrate relevancy, inspire, teach, and can ultimately ensue some type of call to action, you have the beginnings of something truly memorable and shareable.

When using photography to tell a great story or to convey a message simply, quickly, and accurately, we have to first get rid of the words … well, not all of them. Consider Instagram, one of the world's leading social media platforms. It's all about the quality photo feed and the stories it tells. However, I'm sure you've noticed that the amount of photos far exceed the words. As well, the impact of photos far exceeds that of words. Visuals are easy to understand, and as studies show, we understand images quicker than words. It's amazing how glued we can become to a beautifully engaging photo or video feed. A photo is just one of the tools of visual storytelling, and to use a photo effectively, you should never lose sight of the audience. You can, however, lose the abundance of words.

Over 90 percent of information transmitted to the brain is visual. Studies show that when it comes to visual content, the retention of information is much greater than what a person might hear or read. On the business side, especially during business meetings and conferences, information is usually transferred by way of presentation and written content in the form of brochures and booklets. Even when visual content is included in these mediums, it is not usually as engaging and memorable as content that is primarily visually focused. It is true, however, that if verbal language is accompanied by powerful, real-life/real-time visuals, the effect of the presentation can increase significantly.

Whenever you feel compelled to add words and captions or a written narrative to your story, just remember the facts about attracting and retaining your audience's attention, and, of course, never lose sight of your objective in telling the story in the first place. When I announced the launch of this book, I gave a great deal of thought to the type of photo(s) I would use to communicate the unveiling of my new project. I really didn't want to use much in the way of text, if any at all. I finally settled on a photo that had great composition and included everything that would reveal the nature of what I wanted to convey. Yes, there were books, and yes,

the photo gave perspective that would cause the viewer to ask the question—not the "What is going on here?" question, but the "Oh, my goodness, what exciting thing is happening with Pam now that she's an author?" question. The photo was visually appealing and had the "cool" factor. It was perfect. My photo announcement was well-received with lots of congratulatory sentiments and requests for autographed copies … a home run indeed.

In this principle, "less is more" is about verbal and textual content only, and the very opposite is true when it comes to the amount of time you can and should expect to spend in your efforts to tell an amazing, engaging, and memorable story, and to include making the connections necessary for your story to build a community and brand loyalty. It's important to have a clear understanding of the connection between your efforts and the success of your company's story being told well. The very opposite is also true when it comes to the consistency in which you engage and encourage your team in this process. Being consistent and concise about what exactly your vision and message is will be the best way to begin, and become part of your formula for success. Recognize early in the planning and strategizing for your story, that a story told well will have others doing all the talking, sharing and writing

about it … with a consistent message. Proverbs 27:2 says, "Let someone else praise you, and not your own mouth; an outsider, and not your own lips." In order for this to happen, you have to do and/or create something praise-worthy. You may not knock it out the park during the first pass, but the project can certainly be a good foundational piece to build upon, if done well.

Try not to overthink, overdo, or overcomplicate things … another "less is more" approach. You may be surprised at some of your own natural instincts. Listen to them and have the courage to take risks. You wouldn't be in the position you are in if you didn't come with a set of skills and abilities, gifts, and talents. Hold tight to your confidence and try to stay grounded enough in your belief in what you're doing so that fear doesn't take root. Engage in FLOW: Feel Love Over Worry. Anyone working with you on this project will appreciate your ability to keep things simple and your ability to remain calm and focused in the midst of challenges and deadlines. This will always keep the channels for creativity and inspiration open. Less stress and less fear leads to more opportunity for success and the makings for an enjoyable experience for everyone.

We all have our natural ways of dealing with things, and then we have our adaptive ways of

dealing with things. The adaptive style comes into action when we are under stress. It would be ideal if we could always stay in our natural style, but oftentimes stress is unavoidable so our adaptive style kicks into gear when the stress levels are high. What do you want your staff and your colleagues to experience most when collaborating with you? I don't know your natural or adaptive style, but I'd like to believe that anyone's natural and genuine style is always better. When things begin to get stressful, that may be a sign that it's time to simplify things—to get back to basics and re-focus on the objective. It's not easy to remain sure of yourself and your strategy when a host of ideas, opinions, and even resistance are constantly being thrown your way. If you do your due diligence and cast a clear vision, you will find the project more manageable and the people more amenable.

When it comes to DISC, which is a behavior assessment tool based on the DISC theory of psychologist William Moulton Marston, which centers on four different personality traits currently identified as Dominance (D), Influence (I), Steadiness (S), and Compliance (C), I am a high D and S. This suggests that I am high on the spectrum for *dominance* (how I respond to problems and challenges) and *steadiness* (how I respond to the

pace of an environment) behavioral styles, and some would question why I easily express love and compassion having these behavioral styles. Well, first it has much to do with my intimate relationship with God, and second, the DISC assessment doesn't factor in my love language. My primary love language is "time" and my secondary language is "words of affirmation." I strongly believe our love languages play a part in how we engage with others. By the way, if you ever decide to take a DISC assessment, some key points that should be taken into account when interpreting the instrument is: (1) There is no good or bad profile; (2) We are what we are; (3) We each have particular strengths and weaknesses and; (4) Truly successful people are ones who: (a) know and understand themselves; (b) know their own strengths and weaknesses and; (c) develop the ability to study the situations and adjust their behavior. So, what is your style? Be true to yourself, keep things simple, and keep in mind that in most cases "less is more."

Chapter 5:

Content Is Critical

I began to realize that the camera sees the world differently than the human eye and that sometimes those differences can make a photograph more powerful than what you actually observed.
—GALEN ROWELL

"What's all the excitement about?"

I walked into the conference room where several of my colleagues were huddled and talking excitedly about something. They turned to face me when I asked the question. They had copies of the photos I had taken during a recent company event. People always enjoy seeing themselves in videos and photos, and this group of committed professionals was no different. The

photos were candid shots and the team seemed to be impressed that I caught each of them, as well as some others who were not going to be in the meeting we had come together for, completely unaware and during times they wouldn't think anyone would consider important. They each made compliments about the photos and asked if they could have a copy of the photo taken of them.

Before I agreed to share any photos, I was curious to know exactly what it was about the photos that was so impressive to them. The obvious qualities of a good photo were the things they shared first… clarity, color, composition, and contrast. The next had everything to do with the emotion that was captured in their respective photo. When the photos were considered as a collection, everyone said that together they told a story. I wanted them to tell me the story, and so they did. It was wonderful to hear the story unfold and their interpretations of it. The consistent theme was that of a group of specialized, passionate, and dedicated teammates. Our discussion was interrupted by the managing partner, who sped in with an apology for being late. I thanked my colleagues for the kind and complimentary words and politely told them that I would gladly share the photos after they were used for what I intended them for … to tell our department's story. Our

meeting began, and we shared the photos with our esteemed boss.

Please know that I was nervous. I was stepping out of my lane with this idea; not my comfort zone … my lane. I love taking photos but I was not part of the marketing department. I had placed those photos in the conference room the day before the meeting, right at the close of business when I knew no one would likely use the space. I gently tossed the glossy 8 x 10 copies of the photos on the conference room table so that they would spread apart in a way that someone would have to straighten and move them out of our way before the meeting. I knew that once the team saw themselves, the fun would begin. My intention was for my colleagues and the managing partner to see them before I got there. Their initial reaction would be the most genuine, plus I wanted them to discuss the photos amongst themselves. I wanted to hear what I knew in my heart they would say. This would be confirmation about everything I knew and felt in my heart… that for our department to have more of an impact on the company's efforts and bottom line, we needed to tell our story. Aside from the managing partner's late arrival, everything unfolded as I had hoped, including being given the go-ahead to create a marketing brochure for our department; a piece

of marketing collateral that would be printed, as well as viewable and downloadable on our website. Telling our department's story with photography was the beginning of a wonderful journey into visual storytelling. The experience itself led to our department doubling in size. That's what happens when people get connected to those who can address and solve their specific problem or need.

When I have the opportunity, I prefer to leave a Marco Polo message to individuals and groups instead of a text message. So much easily gets lost in translation with text messages and you can't always control the tone of a message. Sorry, but exclamation points and capitalization fail miserably in establishing tone. The same way our family, friends, and colleagues make assumptions when viewing content, you can bet the public does as well. At least our family, friends, and colleagues have the advantage of knowing us on some intimate, familial, or business level. Choosing what to say is even more critical than how you say it because once you say what you say, you can't take it back. Thinking carefully about the context of your message is critical to the assumption audiences will make.

Back some years ago, I had the privilege of gracing the cover of one of my county's local magazines—a magazine with a distribution of 8,000

monthly. I remember when I was being interviewed. I was asked a ton of questions and I gave a very detailed answer for each of them. It wasn't until after the interview that I fretted about my answers. "Did I say too much?" The magazine couldn't possibly print everything I said. They would certainly have to pick and choose. "But what would they choose, and what aspects of the story specifically would they choose to highlight or leave out?" If not chosen well, the story could very well leave readers with wrong impressions. I wasn't asked by the writer which experiences were the most important to me. I also wasn't asked whether there was something I would prefer the magazine not share. I guess if what was going to be printed was a concern for me, I shouldn't have shared anything I didn't want to be repeated. In any event, I slept very little during the weeks leading up to the magazine's debut of my cover story. The writer had a very good reputation and I had read some of her work. The photoshoot had gone well and I was pleased with my wardrobe and makeup. I probably could have put an end to all that concern by just reaching out and asking for a proof, but I didn't. You're probably thinking I'm going to tell you that when the magazine hit the stands, my fear had become a reality, but no, it had not. I was incredibly relieved to read a very accurate and well-told story.

When we spend time gathering the facts, the history, the relevance to the market audience, and whatever other details that will make the story complete, it is critical to develop some key moment concepts. Ideally, the context of the photo or image would be aligned with the narrative, but it's not entirely necessary as long as the narrative is conveyed accurately and correctly. I find storyboarding to be an incredibly helpful method when putting the context of a story together. It helps to plan out an entire sequence of events before I ever pick up my camera. The visuals used in the storyboard can convey your vision in a timely, organized, and cost-effective way. Storyboards also provide opportunities for the company's leadership to buy into the approach and strategy being taken before too much effort and resources are put into moving in the wrong direction. The messaging in the story absolutely has to be aligned with the company's strategic direction. This makes for good stewardship and is always appreciated. If you're not familiar with a storyboard, consider it as an organizer, but instead of text, you would use illustrations or images to capture and express the nature, purpose, and plans for your project. Illustrations and images are displayed in sequence for pre-visualization. It conveys how the story will flow, as you can see how your shots work

together … incredibly necessary to tell the story and communicate the concept. A storyboard is also essential to avoid unnecessary costs or delays in your project. There are several types of storyboards, so if you need some assistance in creating one, I suggest searching YouTube. There are lots of videos on how to create an effective storyboard. It will become clear which type will best serve you and your team.

What you see is not always what you get. Have you ever experienced a company brand that impressed you enough to engage with them, but when you did you were disheartened to find that their brand didn't match your experience? That's crazy, right? Well, it happens. Some companies have phenomenal marketing teams that are very talented in sharing the story they want you to know, not the one that actually exists. Again, your content choices are critical. Keep the fabricated clutter out of your story, and choose to invite the genuine conscience in. An authentic and transparent story, along with being engaging and visually appealing, is the order of the day … always. It seems like I have lots of orders, don't I?

Your people choices are equally critical. Your direct team and the other people employed at your company have much to do with the customer experience. Employees who are not engaged can damage your

company's brand. This unfortunate dynamic is linked to poor quality and service, which ultimately negatively impact the company's reputation. The objective is always to increase engagement thereby minimizing any negative effects that can cause irreparable damage to a company's image.

Shooting the visual elements for your story requires attention to detail. One of the best ways to ensure you are capturing images that will best tell your company's story is to keep the lines of communication open between you and those you are gathering information from. This way, the decision-makers and those providing information can give feedback and suggest changes as the project progresses, rather than creating a final product that is far from the vision others had in mind. Due to deadlines and other timelines, we won't always have time to revisit concepts, or worse, go back to the drawing board. I mean story … board.

As you work through the project and the process of creating your visual narrative, there may come a time when you feel stuck; when things aren't moving along smoothly or as planned. It's easy to grow weary. This is another opportunity to FLOW: Feel Love Over Weariness. When this happens my first suggestion is always to give it time. Some things, especially capturing certain photos that

have the elements you've been planning for, take time … lots of time. You could be taking shots of a subject and predict what shots would make themselves available—the very shots you need, but instead of the shoot taking ten to fifteen minutes, thirty minutes might have to pass before you get what you were hoping for. Hopefully, you've baked-in adequate time for situations like this, into your strategy's timeline. This isn't always the case though. If it's clear that you are struggling and striving to get what you need. If there seems to be a battle or an undercurrent of negativity and dis-ease about the direction you are going in, I would sit back and re-evaluate your original plan. There is nothing wrong with ever so slightly switching directions or gears. It just has to be for the right reasons; especially if you've done the appropriate and thorough due diligence on the front end. If data and market analysis support the decision, that makes it much easier for everyone involved to buy into the change. You just want to be careful not to travel too far down the wrong road for too long. It can end up taking you just as long, if not longer to make your way back; not to mention the money lost by having to shift gears.

I remember on several occasions having to pull an all-nighter to meet a client deadline. I heard my boss clearly as he outlined his vision for the

marketing project, and I asked all the questions I believed were pertinent to getting the project done well. I put my expertise to work, got it done, and met him back in his office two days before the actual due date. He liked what he saw, but apparently, after having had several conversations with the client since he and I last met, some things about the project and overall objective had changed … but the deadline hadn't, and he had not reached out to communicate with me. I did well to mask my frustration. I had worked all night to impress everyone involved and I did impress them. I also took the lessons I learned from that experience and moved forward. The biggest takeaway for me was to establish expectations relative to communications, on the front-end.

I also want to share a time when I was working with a freelance graphic designer for a marketing project. When we met, he asked very few questions, and looking back I didn't see that as a problem because I felt I was pretty thorough in my description of what I wanted in the design concept. I reached out during the days that passed since our first meeting, and never got a response from him. I began to feel nervous and anxious as the deadline for the project was fast-approaching, and unfortunately, I was not prepared with a plan B. Finally, the day before the

project was due, I received a design concept from the designer. Yep, you guessed it. I was not happy. What I received was incredibly well-done, as he was clearly a talented individual. The problem was that he did not take into consideration all that I shared relative to the client and the objective we were working to achieve. He traveled down the wrong road for sure. If he had only returned my calls! We had one night to get it right, and the designer worked all night to get it done. He came through and did a phenomenal job, as that was the only way he was going to get paid. I learned much from that experience. I *always* have a back-up plan, to include switching gears—and people—if necessary.

In most cases, before the creation of an invention, you will find there to be a need or a problem of some sort, and an idea by which to fill the need and solve the problem. Creative minds come together, plans are made, and before you know it, an invention is made and the problem is solved. In this same way, the customers in your market have a need; a problem that needs a solution. Expressing that you clearly understand your customer's need and expressing that you've had demonstrated success in solving a problem like theirs through your narrative may be the single most important opportunity you have to communicate it in a manner that resonates and

motivates them to act. As you can imagine, there are a lot of inventors trying to solve the same problems, and like them, your competitors are trying to do the same. If you are new to your role or not yet established as having the demonstrated ability to do what you've been tasked to do, it will be important that at a minimum, your initial efforts express that you not only understand what the customer needs but that you've taken the steps to assure that the customer's needs are accurate. What does that mean? There will be times when company leadership may not have done the kind of assessment they need to accurately uncover the problem that needs to be solved/addressed. If this is the case, then most definitely, the strategy you'd be working with will not be aligned with what's best for the company. Therein lies the opportunity for you to help your client by digging deeper into the "why" behind their desired efforts and outcome.

I worked for a client that wanted to extend their brand in the marketplace. What they didn't know was that before they could do that, they needed to undergo some change management, a term used to describe significant alterations to an existing business model, philosophy or business approach, designed to improve a company's overall operations. Leading change management involves providing subordinates

with a clear vision of why change is required, the way change is going to be implemented and the anticipated results. Successful change management leadership also involves the input and participation of subordinates to streamline changes and integrate them into a new business model. So, you want to know what extending one's brand in the marketplace has to do with change management. Well, when you don't have the right leadership in place, and employees are anxious, worried and disengaged, it creates a disconnect that the company's customers will undoubtedly feel and experience when they engage with them. The consulting I provided to the leadership of this company expressed that I had a clear understanding of not only their internal needs but what their target audience would want to know to be convinced to engage with them. The purpose of change management is to implement strategies for effecting change, controlling change and most importantly, helping people to adapt to change. I was able to ascertain their foundational need through my assessment process.

With the explosion of visual content, it's important to pay attention and take note of what content is attracting the most attention. Specifically which visual stories are being creatively retold and shared. With so much content being created, you

would think that people are being over-stimulated, but no, there is a constant desire for more. More of the good stuff—the visual content that makes a connection with the audience and visual content that captivates and involves us in a variety of ways, which intentionally includes us so we are a part of the experience. Good content creators can do just that. The story places your customer at the heart of the story, which will effectively empower them and help to impact your company's bottom line.

Your content should clearly and creatively illustrate the challenge your customer is facing and how your company can help them to solve it with outcomes that will impact them personally as well as professionally. The magic happens when your company's story carries just the right amount of vulnerability and imperfection that allows your market audience to see the human aspects of your story—the human side of *you,* which results in developing trust and empathy toward your message. Your customers need you. They just don't know it yet, and you're going to help them to realize it.

So, back to the client I mentioned that needed some change management. I worked with them for several months. I was able to show them who I am as a professional and as a loving, caring human being. The love I expressed to the company and

the employees, changed the climate in their culture considerably. The team became re-engaged and was reminded of all the reasons they loved the company. Morale was high by the time my contract ended, and yes, they hired new leadership. I was definitely in flow mode while working for this company. I allowed myself to be vulnerable and shared my humanness. This instilled trust as I shot and shared photos every day, as well as taught others how to overcome worry and all the wiles of the world. This is the human side of *me*.

When I was employed at one of the "Big 5" financial services firms, I had the opportunity to work for a wonderful man. He was kind, incredibly intelligent, and a wonderful thought-leader. It was during one of our planning meetings that he shared with me, that he and several of the partners in the firm compared the way I interacted and engaged with clients, my staff and my colleagues, with the incredible Maya Angelou. Yep. He said *Maya Angelou*. That comment was right there with Bob's *love* comment. I won't ever forget either of those comments, and I give God all the glory for them. I came to learn further that I was more to my team and colleagues than the position I was hired into. For the firm, I became the leader of the largest client service support group in New York, New Jersey and

Boston, as well as a subject matter expert. And to my staff and colleagues, I was a trusted professional who had the best interests of my teammates and the firm at heart. I imagine the same is true for you. Just like your customers, you just don't know it yet.

It's true. *You just don't know it yet.* I've done work in companies with clients, and the outcome was even better than either I or the client could have ever imagined. I truly didn't know to what degree expressing love would have in everything I do … for real. Meeting people where they're at, with love, breaks barriers and opens doors. When you have a camera hanging from your neck, people aren't always going to be open. Many will go out of their way to avoid you until they trust you. After a few weeks working with one particular client, it was clear to me that the best way to tell this client's story was to do it through their marketing person. What's cool, and a little funny is that I was not hired by this client to tell their story. I was hired to be the photographer for their company events and trainings. However, the photos would soon tell a story. I would take photos and share the photos with their marketing folks. At first, nothing was being done with the photos, but after a few weeks, one of the marketing people could see that a story was unfolding and that if they used the photos as

I shared them, it would spark interest and create momentum, as well as increase engagement from their followers. It was working beautifully and the client offered me a permanent job. I wasn't looking for a permanent job, but the compliment was not lost on me. Love is the foundation to trust, and the foundation for pretty much everything else.

Chapter 6:

People Make Perfect

If a photographer cares about the people before the lens and is compassionate, much is given. It is the photographer, not the camera, that is the instrument.
—EVE ARNOLD

So, how do you tell a story that people want to hear ... I mean see? How do you catch the attention of potential customers? How do you make it engaging, relevant, and relatable? How in the world do you make it memorable? The best way to do this, in my opinion, is to use what you have: the people. Feature people! They relate better to others than to inanimate objects or ideas. Resist the natural inclination to tell the business or product story. Tell the story of what's behind

the business or product—your customers and your employees. Featuring people is huge for making the all-important human connection.

The truth is, there's nothing simple about a photo or illustration that has been masterfully captured or created. It captures and embodies all the aspects of the story you want it to tell. It's complete. It impresses; it evokes emotion; it takes residence in the memory of the viewer, and the image teaches something—not just about the company, but about something or someone related to the company and also about its creator.

It's exciting for me to share my perspective and expertise in this book. As I've said, I've been taking photos for a very long time, and have stumbled, yes, *stumbled* into some pretty amazing and impactful experiences as a result of it—much of which I get to share with you. You may not know how a single photo or illustration can be the most powerful thing your company uses to gain distinction in your market or how it can singlehandedly catapult your company to a place of long-standing notability. You may not have perspective on how your team plays a significant role in carrying and embodying the distinction your company achieves and hopefully sustains.

So, even if you haven't taken photos for as long as I have been, or if you haven't given much thought to how your employees fit into this journey, there's a beginning to everything and an opportunity to shift something that is not so simple into something doable and meaningful. Now, typically it will require a sequence or more of photos to tell a corporate giant's story, but irrespective of the number of shots, the story should be told visually.

I have to say that with a newly-hired strong and talented marketing team, the corporate giant I shared about in chapter 2 continued to produce highly professional marketing materials and video. The illustrations were crisp, the colors were aligned with the company's brand, the data was current and impressive, and while the latest brochures didn't tell the story that mattered, it did share information about the company's results and its ability to get them. The company reminded the public that they were reputable and competitive. But was that the marketing team's objective? Was it only about sharing information and reminding the public that they were still there? I'm almost certain there was the belief that if the company shared their impressive results, it would attract potential clients who would ultimately flock to engage the company to meet their most pressing need. That undoubtedly worked

for a time, as they were incredibly successful in the acquisition of new clients. It wasn't long though before the competition loomed and marketing strategies became more creative, sophisticated, and, above all, *visual*.

It was my son's senior prom. He was happy to be going with the girl he secretly admired for years before she became his girlfriend. He was proud of his tux. What he was most excited about was his pink dress shirt and brightly-colored paisley tie. My son didn't know it, but he was following in his dad's footsteps (he wore a purple tux and a multi-colored bow tie at our wedding).

My son allowed me to use the lint brush to lift any microscopic pieces of lint from his tux. He allowed me to make sure his tie was straight, and to make sure there wasn't some random piece of anything on the back of his head. He even allowed me to take photos of him at our home. What he absolutely did not want me to do was to show up where he was to meet his friends and his girlfriend.

I couldn't let that slide! Instead, I decided to be incognito. I showed up with my strongest zoom lens along for the ride. I took all the photos I wanted… from a distance. I even asked the restaurant owner to take candid pictures of my son with *my* camera! He agreed, and I was thoroughly satisfied. My son

and his friends wanted to have a solo, young-adult experience. The whole thing was tolerable for me because none of the other parents were "allowed" to show up either. I waited outside down the street from the restaurant, enjoyed the beautiful sunny day, and read until I received the call from the restaurant owner that the students were done and heading out. It was fun. I felt like I was on a secret mission.

A few days after prom, I download the photos for all the family to see. Man, were there some *great* shots. The restaurant owner told me that he used and owned the same camera as mine. The further into the photo slides we went, I could see confusion slowly appear on my son's face. Before we got to the end, he asked where the photos had come from. I told him that I took them. He said that was impossible because I wasn't there. I responded that I wasn't sure what he meant. That frustrated him. He said, "Mom, look! In this photo right here I am looking directly into the camera. How is that?" I shook my head and shrugged. He was confused and became even more frustrated. I could hardly contain myself. After a little more back-n-forth, purely for my enjoyment, I told him about the arrangement I made with the restaurant owner. His eyes opened wide and then he burst out laughing. He should know by now that he can't keep his Momma out!

The photos from the pre-prom dinner were perfect. They were all candid shots of my son, his friends, and their dates. Great shots that told the story of their confidence, their friendships, their desire for independence, as well as the fun they were having imitating grown-ups. That's what it's about. Letting people tell the story… even in your business.

So, how can what I did to get the photos of my son help you? How can you overcome resistance? Well, the way I see it, when you can be as creative as I was when obstacles stand in the way of capturing the shots you want and need, you are more likely to be successful in getting what you hope for. There is a local business in my community that was creative in going through a great deal of political red tape to reserve access to some public space to hold a community event. They would have to go through one committee after another to convince them that this event would be a benefit to the community at large. It would take months of waiting to get on committee meeting agendas to present their proposal, and then there was no guarantee of approval. Instead, they decided to make personal invitations to the decision-makers. Free tickets were offered and before you knew it, a date was set. The event was a success with lots of community goodwill. I took photos for this event, and the story these photos told opened the

door for this event to become an annual one, with no resistance of any kind from public officials. The annual event has grown tremendously and is much-anticipated by community residents. The company still uses the photos from the inaugural event to market and publicize the event each year. Photos of people who work for the company and who are serving with a clear sense of joy; photos of guests (and the decision-makers) enjoying themselves and one another; photos of an event that welcomes family and community. The story caused people to ask, "How can I be part of this?" This company's business does well with its well-told visual story. Their creativity in getting around some pretty strong obstacles paid off.

Everyday people do everyday-type-things, and this is the stuff that other everyday people can relate to. Share true stories and choose to share the more personal side of people to have a greater effect on how others perceive your business. Let the heart of the people shine through. Let your heart shine through as well.

Speaking of heart, it was a sunny and clear Tuesday afternoon when my sisters and I each received surprise packages in the mail. I got a call from the youngest to show off that she had received a package from our mother that day. She was surprised

and happy when I told her that I had received one too. While we were on the phone, the oldest sister sent a text to the two of us to share that she had received a package from Mom. We immediately got on a three-way call and squealed with delight over the beautifully crocheted cover-ups our mom had made for us. What better way to celebrate than with a photoshoot. It was the perfect way to express our love and appreciation to Mom. All three of us met in a centrally-located park. We spent about two hours taking some beautiful photos. We had them printed and sent them to Mom. To this day, one of the shots from that day is still my very favorite photo of the three of us. We told a story of sisterhood, spontaneity, creativity, and gratitude, all through photos that day. The cover-ups were beautiful, but it was the three of us, the people, who visually told the story.

While your vision, your plan, and your storyboard will keep you organized and focused, you have to leave room for some spontaneity. My sisters and I did not plan to have a photoshoot that day, but man-oh-man was it a memorable one. It blessed my mom as well. You never know how an unexpected opportunity can elevate your story. You never know how a small detour may open the way for something amazing that you and your team never thought to

consider. Try not to keep such a tight schedule in your project timeline that you can't take advantage of what could be a golden opportunity. Inspiration sometimes comes in the most unsuspecting ways and at the most unexpected times.

Human beings are visual creatures, and, as such, the time is right for companies to implement new solutions to leverage their human capital to tell a creative and engaging story. The great thing about visual storytelling is that there's no limit to how creative you can be, and the more creative you are, the more likely you are to be successful in attracting your key market. How exciting is it to know that you have the freedom in creativity to do whatever you want? Take advantage of this. Featuring the people you have, those you are connected to through your business, are the way to go. Get them involved and see how far your creativity goes in telling your company's story. There are so many possibilities that your team, your existing customers, and every level of management can offer when you just open the door to them. Make it a point to experiment and take risks until you find the right mix for *your* recipe for success.

Chapter 7:

Build Your Brand

It is one thing to photograph people. It is another to make others care about them by revealing the core of their humanness.
—PAUL STRAND

As an author, personal branding is important to me. It also provides flexibility and some ease in transition if the employer I'm working for or the business I'm contracted with decides to shift its focus or strategic direction. Having a brand of my own allows me to remain consistent and true to what it is I provide in the way of products and services. I love the flexibility and I am consistently building my credibility and increasing my visibility. In my

line of work, a potential client is always assessing my qualifications—my experience, expertise, and talent.

As I live my texture, a phrase I like to use to describe my truth and authentic self, I can see how important it is to establish boundaries for what is most acceptable for my best and highest good. I can also see how important it is to those around me, and the rest of the world, for that matter. I am here for a purpose, and, at a minimum, I am here to serve by using the gifts and talents God gave me.

Without putting any intention behind it, Oprah Winfrey became a brand. In an interview, she talked specifically about being consistent and being true to who you are. She says that she became a brand simply by making choices every day that felt like the right move. From there, she'd make another choice that felt like the right move and then just continued to make a series of right moves over and over again. Before you knew it, she became a brand. Cultivating your brand helps you to stand out from the crowd and it brings out the best in you. Always remember the golden rule about branding—be authentic.

Your company's brand is its reputation. Building, strengthening, or broadening your company's brand should always be a key impact strategy. Make no mistake about it: a recognizable and loved brand is one of the most valuable assets a company owns,

and you should note that branding is so much more than just a cool logo or a well-placed ad. Branding doesn't happen overnight or even in a few months. Building a brand is a process that is well worth the effort and the time it will take to become recognized. Your ongoing effort will result in establishing long-standing relationships within your market.

Talking with team members, clients, colleagues, and especially taking the time to interview people who have the problem you know your company can solve, is an important exercise and time well-spent. The information relayed in these discussions can help to ensure you're not just in the right ballpark, but that you're on the right path to a home run. What are their perceptions about your company? You'll find they have specific ideas about the culture, the services, the products, and the company's reputation. Take nothing for granted. One could only hope that the ideas and perceptions are good and consistent across the board, but also consistent with what *you* think, believe and experience about the same. If not, you have even more work ahead of you. If there are inconsistencies in how your company is seen in-house and in the marketplace especially, you have to get to the core of why. What is causing confusion in the messaging? More often than not, it has much to do with leadership and the absence of a clear—and

clearly communicated—strategic mission, vision and direction. Further to that, whatever is being conveyed is being interpreted differently amongst the different groups, and worse, no one sees where they fit in it all. If you find yourself in this scenario, this would be the perfect opportunity for some serious discussion with leadership about who you are as a company; what you do; what your target audience is; what your value proposition is; where you want to go; and where do the individuals who make it all happen, fit. Answers to these questions are critical, and equally critical is the team of people who play an integral role in the answers.

So, how will you go about generating awareness about your company, its products, and its services? Your marketing strategy will no doubt include a series of campaigns to gain traction in your market. Once you settle on your narrative and the images you want to use to visually relay it to potential customers, you will have a host of digital delivery methods to choose from.

The foundation for building your company's brand is to be crystal clear on the target audience. I mean that you have to get very specific about knowing who it is that you are trying to relate to, and as you do, figure out detailed behaviors and lifestyles of your consumers. This will be the audience that

will best identify with your brand identity. During this process, you may come to realize that the competitive advantage when branding your business is to narrow your audience focus. This can help to ensure that your brand message comes across *crystal clear* to the intended audience. I can't stress that enough. Your target audience shares similar needs or characteristics that your company hopes to serve in some capacity. Narrowing your audience focus helps to ensure that your marketing and communication strategy is effective in targeting this specific group of individuals or businesses. When done well, your market audience will easily relate to your message, and what you are conveying in the way of products, services, and solutions to their problem(s). The visual story will resonate with them just as easily.

It's important to consider your company's competition in the marketplace. You'll want to do some research if it's not clear to you who your competitors are. If you are aware of your competition, how clear are you on their branding? Is their messaging and visual identity consistent across channels? What is the level of quality of their products and services? Are there any reviews you can read about your competitors? How do your competitors distinguish themselves in the marketplace? Are you under some impression that you don't have competitors? If you

are, I would lovingly encourage you to look further and deeper because the likelihood of your business not having any competition is slim to none. You will find the answers to these questions to be incredibly helpful to you as you build your brand. Customers in your target market aren't looking for another cookie-cutter company who offers the same thing as everyone else. They are looking for an experience tailored to their needs backed by genuine personal interaction.

The first thing most people think about when building a brand is arguably the most exciting part: the brand logo. Your company's logo will ultimately be the single thing that can recall and tell your company's story the moment someone sees it. The logo will appear on everything that relates to your business. It will become your identity and the visual recognition of your commitment to your customers. Because of this, the time and money you invest in creating something exceptional are well-worth every bit.

If you are wondering how to brand your company uniquely, work to make your personality stand out in every aspect of your brand building process. As the creator of your company's brand, the unique opportunity for your creative style to shine through is one that you will want to take advantage

of. Your God-given gifts, talents, sense of style, and photographic expertise will all contribute and influence the development of your company's brand and its story. When you go to museums and view the work of certain artists, most times you can tell right away who the artist is based on the style of the painting or the sculpture. The same is true for you and the unique style you bring to what you create. Some photographers prefer to take black and white photos only. You have street photographers who only capture action shots with a certain background, and you know it's them. Some of the most renown photographers, videographers, and filmmakers have specific styles that make their work easily identifiable as theirs. What's *your* style? What's *your* thing and will it benefit the story you need to tell? Will your style help to distinguish your company's brand in the market industry? If you are not the marketing and communications manager I intended this book for, then, by all means, hire a professional designer or creative agency with branding and identity design experience to help you build your brand. Your brand message is an opportunity to communicate on a human level, making a direct emotional connection with your consumers.

Remember, your brand should be visible and reflected in everything that your customer sees. You

must stay true to every aspect of your brand, unless, of course, you decide to change your brand into something more effective based on measured consumer response. Inconsistency will do its job in confusing your customers, as well as making long-term brand building more difficult. There is no compromise to be made when it comes to making sure your brand is integrated into every aspect of your business.

One important component of successful branding is consistency. It's the most effective way to build brand awareness. Consistency is what leads customers and clients to engage with and purchase from certain brands. It's the ones they recognize the most for their consistent image and content schedule, that make them more likely to be purchased from. Ensuring that both your messaging and visual branding are clearly and consistently applied across all communication channels reinforces and strengthens your identity and instills trust in the hearts and minds of your target audience.

Once your brand is established, it needs to be everything, everywhere, and available every time your company is referenced in any way. Your staff and colleagues are key to brand awareness. Everyone has to be singing from the same songbook, so to speak. Any inconsistencies can have a significant impact on your brand recognition and can lead to

confusion about your company's identity … not to mention slowing down the brand's ability to create awareness in the marketplace. Ideally, there needs to be ownership somewhere in your company relative to its brand. Many companies are hiring brand managers for this specific purpose. If the responsibility of brand consistency is not housed with a responsible individual or team, the company risks getting lost amongst the myriad of competition.

If you need to develop a logo and brand message, there is a host of marketing guru's to choose from. If you do decide to go the route of engaging and hiring a marketing professional, I'd like to offer this advice for your search: Start with asking people you know and trust for a recommendation, and it would be ideal if they have actually used or worked with the person themselves, or if they can directly connect you to someone who has—someone *they* trust. I would hope that the marketing person is willing to meet with you in person. Yes, I appreciate that in today's world meetings can be held virtually and that this option may be more convenient, but in my opinion, there is too much at stake with this project to make a selection over the airways. How you feel when you and the person are together will speak volumes about whether the two of you will work well together. Be sure to ask to see some of their work—their most

recent work that is most related to what you would be contracting them to do. If there is a website, social media, or other online presence, please look at them all. Lastly, if all moves along well, consider that their proposal to you is of the highest quality, and represents exactly what you shared with them as it relates to the project details and outcomes. There are plenty of "marketing" professionals to choose from so let's make sure the one you choose is a great listener, as well as incredibly talented. The talented marketing people are not cheap, so be prepared.

Ok, so you absolutely cannot meet in-person with the marketing professional … it's just not feasible. While Zoom is my go-to online video chat/conferencing platform, there are many other reliable and user-friendly options to choose from. Most are free up to a certain number of participants. There are online marketplaces like Fiverr where you can find individuals who provide digital marketing services at every level. The good thing is that there are many freelance professionals to choose from and the cost is not as hefty as going with a private company. Digital services in more than 250 categories are available. I've used them for the sole purpose of generating ideas for a project I was working on. It was worth the minimal investment to lay the foundation for what I ultimately created for my client.

If your business goal is to generate revenue, then you have to do some kind of marketing. If you want to attract and maintain customers, if you want to consistently exceed the expectations of your customers, there is a science to this, and an outstanding marketing person knows it well. There is a professional marketing person in my community whom I admire a great deal. She just celebrated ten years in business and calls herself the marketing guru. She built her business from scratch and quickly established herself as an expert … I mean, guru. Because marketing is at the core of what drives revenue for businesses, it's no wonder it is expensive. The return on investment can sometimes happen with the engagement of just one client, depending on the nature of the business/industry. Competition is steep as your competitors are vying for the same audience. Yes, competition is steep. Even if you feel like you have only one competitor, if that competitor has an awesome, impactful marketing strategy, then your competition is steep. It takes experience, expertise, and resources to take a value proposition to execution.

Your marketing professional needs to have a diverse skillset or at a minimum have access to professionals and resources to fill any gaps. A successful marketing plan will include website development,

content strategy, branding strategy, search engine optimization, social media marketing, pay-per-click, and email marketing. Whether you use the marketing professionals you have in-house or you look outside the business, a marketing team should be connected to every part of your company. They are the people who should be connected with everything from the product to the customer service lines.

Chapter 8:

Conflict Is Compelling

I think that emotional content is an image's most important element, regardless of the photographic technique. Much of the work I see these days lacks the emotional impact to draw a reaction from viewers, or remain in their hearts.
—Anne Geddes

Conflict is the backbone of any good story. The tension that is created with an unresolved problem is what keeps us engaged to find out what happens in the end. Conflict is very powerful in visuals that your audience can see early in your campaign story because the very thing or situation needing attention will get them hooked and keep them interested enough to stick around.

While there are many reasons a company's story can fail to engage its market, the primary reason is usually that the story lacks the essential component of effective storytelling: a problem that needs resolution. Think of any story you enjoy and you will most likely find a challenge of some kind at its core. Unresolved conflict is the source that drives a story. When there is nothing to be addressed or resolved, there is no story. The bottom line is that strife and contention spark interest.

Conflict is the problem that needs to be solved. How can a brand solve my problem? How can a company's story compel me to believe that they are a resource that can help me? Customers will be less interested in your story if it isn't relevant to a conflict or problem they are struggling with. Every novel, play, movie, and TV show is based on some type of adversity. The simple fact is that a good story requires resolution to something. When conflict causes stress, it's because a solution has yet to be found. Solutions are often choices based on circumstances, the nature of the problem, and who's involved.

It is extremely important to the success of your brand's visual campaigns for some form of conflict to exist. Viewers will engage more with a visual story that tells an exciting story which includes a challenge that needs resolution. Some of the most memorable

stories are those with lovable characters the audience can root for. The lovable character should best represent your audience. Another foundational aspect of any successful story is how relatable it is to your audience. Using photos that look most like your audience and speak to their needs opens them to wanting to know more of what you have to convey and offer. It pulls at the heart when the audience is compelled to root for "one of their own."

Now, before you set about work to convince your company's target audience that you have the solution to their problem, you would do well to make sure you don't have any internal challenges within your team or amongst your staff that need addressing. I don't know why, but this makes me think of the professional hairdresser or barber whose own hair is a complete mess. Now, why would I believe that person can do my hair?

I was moved to tears when I saw the heartwarming Google ad that showed old friends coming back together after many years. It tells the story of two old men in India and Pakistan who were childhood friends. The men used to play together as boys but became separated and drifted apart. Of course, audiences like me get to watch as the two men are brought back together through the power of the internet. The stress of the one old man who was

missing his childhood friend is something that many of us, myself included, can relate to. This is the strife, the conflict in the story. In life we get caught up in our day-to-day and don't spend as much time with those whom we enjoy; jobs and family dynamics cause us to move away from loved ones, and whatever else seems to get in the way keeps us separated and disconnected. We know how it feels to be reconnected with a long-lost friend or family member.

So, how does the conflict get resolved? Well, as Google reveals the answer, we stick with the story because we want to see that the two friends are reunited. We root for them and prepare to cheer—or cry—until they are finally able to embrace after decades of being separated. The answer: it might not have been possible without Google or the precedents Google sets. The Google ad spread through the web and into our hearts... powerful, indeed.

I don't believe anyone intentionally sets out to choose adversity, but I do know that in this thing called life, it is unavoidable and we must choose how to deal with it. "Choice" is the operative word here. Through visual storytelling, a company has an opportunity to speak directly to a customer in their specific market, about how it can uniquely solve the customer's problem. Many brands that hear the

word conflict and want to move in the complete opposite direction will find themselves questioning their inability to penetrate their core market. Customers will question your company's relevancy. Your company must consider a dilemma that your target audience has a great deal of interest in having a solution for, something potential customers fear, want, and care about. Of course, it needs to be a challenge that your company has proven its ability to successfully overcome. When done well, your content, your ability to creatively use photos to tell the entire story, will stand a good chance of resonating with your audience.

I used photos to tell the story of my sister's battle with ALS. The conflict was not just that she had the disease and all the pain and discomfort that accompanied it, but also the stress associated with insurance, finances, social workers, and equipment. The story is not an easy one to watch, and it certainly wasn't an easy one to capture. Capturing it was made more difficult by the lack of understanding of family members who questioned why I would take pictures of such painful things, but on the other side of the experience, most are thankful we have a record of the journey. And yes, it is an incredibly sad story, but it includes a great deal of learning, a host of experiences, a hero, and, in the end, peace in the

absence of pain. There is a compelling element to the conflict. For most of us, we want a happy ending. We want the happily ever after. I believe that amid conflict, there is love and hope. There has to be; why else would anyone care or hang around? They stay engaged for what they can only hope will be an outcome that was worth waiting, and watching for.

As soon as the conflict is resolved, we feel better; at least I do anyway. It's like how you feel when the character you relate to most in a book or movie, gets what or who they want in the end. They get the gold or they get the person they've always loved. You know what I mean. The character is happy and so I feel happy. I've been cheering for them since first being introduced to them and learning what their problem was. I am thrilled when there's a happy ending. When you tell a story that easily and quickly resonates with your target customer, and they see themselves as the person with the same problem they have, they too will be cheering and happy when the problem is resolved.

Chapter 9:

Ordinary to Extraordinary

One advantage of photography is that it's visual and can transcend language.
—LISA KRISTINE

Take the audience to a hidden place that they don't get to see every day. Good stories are always about people we can relate to, taken to extraordinary places or circumstances. How can your company do this? Take them behind the scenes. Show your market audience what they wouldn't normally see, but let those things be seen through your or your employee's eyes. When you use people, and you should lean towards having people in your photos, they should be doing what they do naturally. Make sure you are always in the background ...

watching and waiting to push the button on your camera … taking photos constantly. Constantine Manos said, "By choosing a precise intersection between the subject and the moment you may transform the ordinary into the extraordinary, and the real into the surreal."

In an interview with the Leica Historical Society of America (LHSA), an independent, nonprofit membership organization dedicated to everything regarding the Leica camera, Mr. Manos shared this thought: "'The magic moment' only happens once, never happened before and will never happen again, and that is what is so special about the magic moment." So, you can see why it is so important to be ready. The magic moment has depth and interest with people. There are no two faces or bodies that look alike. It's like fingerprints; there are no two sets alike.

The action photos I've captured are some of my greatest examples of capturing truly memorable moments … unexpected, hearty laughing, an "ugly cry," the reaction to a surprise, and those "once-in-a-lifetime" moments. I have quite a few favorites but regardless, the most special part for me as a photojournalist is the story these photos tell. Imagine using your skill and capturing the unexpected, to tell your company's story; to build, broaden or

strengthen its brand. You will be surprised what you will see once you set your mind on what you want to capture. Premeditate in a positive way. Think about how and what it will feel like to step out of your comfort zone. Yes, uncomfortable is right. But you have to see that your comfort zone is where the ordinary lies. We want to step out and get comfortable with being uncomfortable. We want to do things differently from the way we are used to doing them … asking a stranger for a photo, and yes, possibly being turned down; but imagine if the stranger was to give you the go-ahead? How filled with positive energy would you be? Things would start flowing then, and the extraordinary would start to present itself.

Yes, excellent photography is difficult. It takes some photographers years to hone their craft. With today's sophisticated technology, *taking* pictures is very easy, and with countless apps and filters at our fingertips, people can be incredibly creative. The difference, though, comes with the expertise of being able to *make* a picture, the foresight to know which photos will tell the most compelling story, and the knowledge about the best and most impactful way to share it.

Going from ordinary to extraordinary has everything to do with passion. Your passion has

to come into play to tell the story you want to tell well. Your passion will be the excitement and energy that drives the project and keeps those who you are working with motivated at every step in the process. Going from ordinary to extraordinary is all about leveling up, starting with the highest level of expectations for the outcome of this project. This is not the time to be boring and practical. This is the time to think out of the box, extend yourself beyond your comfort zone, and when you think of something ordinary, replace it with a thought that is the complete opposite. In other words, think about the kinds of images people will expect to see, and then think about and produce something very different. Talk about getting the creative juices flowing! I mean, what other way are you going to tell a story that motivates customers to choose your company over your competitors?

In my early years as a corporate professional, I learned and heard over and over again from leadership and colleagues, that I am a people person. "People person" is the phrase candidates believe potential employers want to hear during an interview. They believe the employer wants confirmation that you'll get along with the existing members of their staff. Well, yes, I am a people person, but not in the way you think. You see, I'm blessed that God continues

to place the most amazing people in my life. Some would argue that I play a part in attracting these people, but I don't know. What I do know is that God has blessed me with the ability to communicate and express love in a way that cultivates and strengthens relationships with the people He places along my life's journey. When you work with businesses and teams, and when you want the freedom to take photographs in their spaces, a gift such as this is a blessing indeed.

Speaking of blessings, my older sister is a creative spirit. She likes to do things in a manner that speaks to her artistic side and that which will be memorable for all who are involved. Back some years ago, before printing invitations on anything other than paper became a thing, my sister hosted a dinner party and had the invitation for the event professionally printed on beautiful linen placemats. I still have that invitation displayed in my dining room. She's held a good number of creative and memorable events since then, and each one is unique in its special way. I imagine that like me, my sister's guests can remember the special little touches that made that event memorable. Her recent "tea party" was a big hit with tasty, specialty-blended teas, made extra special with top-shelf brandy, good food, good people with good vibes, and an outstanding female

saxophonist. Yours truly was the guest speaker. I share this example of my sister's exploits to highlight the importance of creative expression to distinguish yourself and ultimately create your brand. My sister's events are well-attended. Her circle of friends and colleagues have come to expect that anything she does is going to be memorable, as well as worth their time and money.

Finding creative ways to stand out takes thought and creative expression. Having a diverse team to work with on your project can lend itself to having a wonderful source of ongoing ideas. Veteran photographers will tell you that taking the time upfront to give thought to how you want to present your project, yourself, or your company, is time very well spent. You'd be surprised by the ideas that will come to you when you choose to be still for some time. Predictable and obvious are all around us. Predictable is what's expected, and when something is occurring in a way that is expected, that means it could translate to *boring!*

I know you understand that visual storytelling is the way to grow your company's brand. The story, the extraordinary story you tell will attract clients and make personal connections with the audience. For me, it's all about the photos, and I acknowledge that sometimes we can make more of an impact with

enhancements and illustrations. If you have this skillset, then, by all means, go for it. We've already talked about the freedom you have to do anything you want that will positively distinguish you, your company, from the others. To further my point about today's technology, it's easy to take a decent photo with the touch of a button, but a beautiful painting … not yet possible with the touch of a button, so, please, bring your other creative talents into play when and if necessary, with as many eye-catching elements as appropriate. We'll talk a little more about eye-catching elements and which tools to achieve them later.

There is an abundance of stock photography for you to use, which is good, but I would encourage anyone with photography skills to use their own photos. I like putting my stamp on my work. I like, whenever and wherever possible, to support my brand with the high-end, quality photos I take. If you don't have the skill but someone on your team does, let them have at it. You've already cast the vision, and by now everyone is incredibly clear on what your focus for the story is. I would open the door to this idea, instead of choosing to use stock photography. Extending this opportunity to someone on your team can go a long way in helping the members to feel a sense of value, responsibility

and, inclusion. Please don't misunderstand. I'm not averse to using stock photography. No, not at all. I'm just suggesting that if you or someone on your team has the skill, use it. It will contribute to the passion you need to bring this project to completion in a meaningful way. The easy way isn't always the best, most creative or heartfelt way of getting something done; especially not something this important.

As you make your photographs and other visuals the focal point of your narrative, keep these high-quality and affordable design tools in mind. They are the ones I use: Canva for web and print media documents; Prezi for engaging and visually appealing presentations; and Venngage for infographic designs that have converted data and processes into more accessible and memorable content. In my opinion, these are the most user-friendly, and most cost-effective with a significant amount of creative options. If you have favorites, please share!

Remember, we're working towards capturing and holding the audience's attention. To me, going the extraordinary route is synonymous with this goal. By the end of your company's powerful story, the customer will be more apt to remember it. "Ordinary" just won't accomplish this … not today. They won't even stop to see the story at all if it's ordinary.

Chapter 10:

Intentionality Is Integral

The whole point of taking pictures is so that you don't have to explain things with words.
—Elliott Erwitt

"What you think about, you bring about." This is what you hear a lot when people are trying to manifest change in their lives. It comes to mind for me when I think about focus. Telling your story, your company's story needs to start with your ability to know exactly the story you want to tell. It means being intentional and focused. Whatever you think about as it relates to this project is what you can potentially bring about with focus, so it's going to be super important to think positively about every aspect of the project.

I am intentional about having a dedicated space to work on my projects, about the medium I use to capture the details of my projects (where the strategy, task lists, and spreadsheets are housed), intentional about the capacity for my project and the steps on how to build it, about the budget and the timeline … I am intentional and organized about every single thing. It may seem overwhelming if you're not an organized person, but I can assure you that being intentional on the front-end about every aspect of the project will be time and energy very-well spent.

To prove myself in my niche, I had to be willing to work earlier, longer, and harder. I had to be willing to be patient and stay in my creative space despite distractions and growing weary. I had to be willing to experiment and take risks. I had to be willing to be uncomfortable for however long in order for inspiration or something unique to come, and to do whatever I needed to, even if I was trembling. I had to stand alone and take criticism from those who didn't understand my vision. To prove myself in my niche, I had to take initiative in everything I needed to do. I had to seek out others who have achieved what I wanted to achieve. I had to be willing to listen even when I thought I had all the answers. I had to muster the courage to put myself out there. That's just how it is when you start. And if you're not just

starting but want to up-level or expand your brand, self-discipline and self-motivation are the order of the day ... I mean every day.

The biggest time-sucker is to start shooting or executing some phase of the project, and it's clear you haven't prepared well. You find yourself wasting time because you don't have everything you need on-site, perhaps you didn't communicate well to the team what the timeline and expectations are for a certain phase of the project. I know you didn't even think to bring a spare battery to one of the shoots. No, I don't know you or what you think about, but I encourage you to dot every "i" and cross every "t." You and your team will be thankful you did. Here's another thing about being prepared: you and your team have needs as well. There may be times when your project takes you to a location where restrooms are not readily available. Yes, you do need to think about where the nearest restrooms are. I don't know about you but I'm not able to be at my best, or even able to concentrate fully if I have a pressing need to "go." Believe me—it all matters. If you are not that detail-orientated, add someone to the team who is, and if you are very detail-orientated, it never hurts to have another type-A person on the team.

I just finished a project where I was contracted to lead a team that was responsible for capturing and

facilitating a business event. I was the only detail-oriented person on the team, and considering the size of the project, we all would have done much better if there was at least one other person like myself on the team. During the beginning and planning phase of the project, I asked if there was anyone whose *thing* was paying attention to details. I got a quick response from one of the women assigned to the project. No one gave the slightest inkling to the fact that this woman's assessment of her abilities was the farthest from being accurate. She failed miserably and dropped the ball with the majority of what she accepted responsibility for. The situation caused a great deal of stress for everyone involved: especially me. All went well for the client. They never knew about the challenges behind the scenes—that's part of my responsibility; not to mention the importance of maintaining my reputation. So, I made sure of it. I trusted the client's judgment regarding the professionalism and skill set of the people chosen for the project. Man, I was blindsided by that one!

I do work to avoid being in any type of reactive state during any of my projects. I make sure I have enough of a buffer between gigs to have time to properly prepare. A complete understanding of my client's desire and expectations, the strategy, and task lists are at the top of preparation. I am in a state

of intention by giving thought beforehand, to every aspect of the project. I reserve time to think about what exactly I need to capture to tell the story so that it exceeds my client's expectations. Getting in the right mindset and being intentional is integral to your success. Once you've started, once you're shooting… it's too late.

It would not be uncommon for the mistakes you've made in the past to creep into your mind. Evict those thoughts from your mind as quickly as you can. Replace those old thoughts with new, fresh, positive thoughts. You don't have time for a trip down memory lane, especially if memory lane is paved with negativity. Remember, what you think about you bring about. I know there's a lot on the line, especially if you are new in your role or your company is at risk of becoming irrelevant in the marketplace. Well, this is even more reason to be intentional about building yourself up, preparing well, and surrounding yourself with everything and everyone who will lend to the success of this project. We want to add this experience to our list of positive ones.

I had the pleasure and honor of shooting a "leap of faith" event. The client had begun generating enough money in her side hustle to leave her stressful, dead-end, nine-to-five job. The money she was bringing in was just enough to replace her full-

time salary, and she knew that to create the life she always dreamed of, one of financial independence, she would need to have the time available to invest in her entrepreneurial venture. She submitted her two-week notice with her employer and then contracted me to tell her story. The experience was amazing, and a first of its kind for me.

It wasn't like a birthday or anniversary party where I would be clear on what exactly I would be capturing. Of course, there was the celebratory aspect of the event, but the emotion and movement shots would be the key. In preparation for any project, I spend time during the contract discussion to become clear on expectations, and as the discussion unfolds it becomes clear how being vision-minded helps the client and me come to a happy agreement. There were equipment and tools I would need to bring with me to this event that I would not typically have thought to bring along … the result of great communication and intentionality.

The event was amazing. The client is an amazing woman, and what she embarked upon was super exciting for her and her family. When I sat down at her kitchen table and watched her and her husband's expressions as the story of this 'leap of faith' event unfolded, I couldn't help but feel connected to them both. I was part of it—their special moment—and I

felt honored. I know that I express love to my clients through my work. Like Oprah Winfrey shared in her Spellman College graduation keynote address, "I am living a life of service through my gift and passion." What I created through photos for this client would allow them, and anyone else they chose, to relive the moments, to feel the happiness, and to enjoy this special story over and over again. They expressed their gratitude not just by honoring the contract they signed but also by the number of referrals they've since sent my way.

The reciprocity between me and the people I provide a service for certainly keeps me in a spirit of gratitude and other positive emotions. All of which can be contagious. I show up happy and almost always, the happiness spreads. Employee and team happiness have increasingly become a business imperative because there is growing evidence that when your employees are happy, the organization can thrive and grow. One study shows that happy employees are up to twenty percent more productive than unhappy employees. The good news about happy employees and teammates is that there is a greater probability that your customers will have a "happy" experience as well.

In his book *The Truth About Employee Engagement*, Patrick Lencioni suggests that being

happy in the workplace is about feeling like who you are matters and that what you do adds value and has a direct, positive impact on the organization. Companies that focus primarily on the financial side of things often fall short when it comes to keeping a pulse on the people side of things. I can tell you that at a minimum, being intentional about the energy and attitude you bring to a project, as well as being mindful about how you engage the individual members of your team, is integral to the success of the project … and whether or not you have happy and productive people working alongside you.

In Mark Miller's book, *Win the Heart*, there is a section that speaks specifically to how *care* builds the foundation for caring; not just for the company, but for the people who are instrumental to the company's success. Mr. Miller believes, as do I, that leadership is responsible for creating a workplace that generates massive levels of care. Try to keep this idea at the forefront of your actions and the messages you convey to your team. I imagine that when all is said and done, you will have been instrumental in elevating the engagement level of your team.

Chapter 11:
Movement Is Meaningful

The best thing about a picture is that it never changes, even when the people in it do.
—ANDY WARHOL

In this section, there are two aspects of movement I will address. The first is movement within the photo. I mentioned earlier that the action shots I've taken through the years are some of my favorite photos. Action shots include movement, and movement in visual storytelling drives audiences to continue throughout the narrative. The second is when you, the photographer, moves around to capture photos from different angles. Both aspects are important. The benefit to taking photos, even the same item or subject, from multiple angles is because you may

be pleasantly surprised by what message a particular angle might convey as compared to other angles.

Not only does good movement suggest energy in motion, people always find it interesting to hang on to see or contemplate about the destination or the landing place. If the photo of the cat suspended in mid-air over a table fully adorned with hand-blown crystal doesn't suggest movement, energy, and a little suspense, I don't know what does. Your eyes become drawn to all the fragile items on the table that will undoubtedly get broken if the cat falls too soon. You look at the photo for other potential damage. If there are people in the photo, you look for the shocked looks on their faces. Perhaps your heart is such where you automatically look for a clear spot for the cat to land without any casualty. I have a photo of my daughter where she has just emerged from being submerged in a swimming pool. She's shaking her head, and you can clearly see each drop of water as it flies from her extra-long braids. When you look at this photo, your eyes move to the very dry, sun-drenched vacationers sitting on the lounge chairs within range of the water flying from my daughter's hair. You can tell she's shaking her head simply by the flying drops of water, the position of her body, and the angle of her head. That's movement. Interest is created and so you linger on the image. Will

the water from the braids land on the sunbathers lounging near by? Will the waiter who is walking by at that very moment try to dodge the water, and in doing so drop the tray of drinks he was carrying? These are the kind of questions a photo with good movement will create.

Take lots of photos ... shoot, shoot, shoot! Why do I take so many photos? First, I want to have plenty to choose from when I get back to my office. Blinking eyes, chewing, screwed up lips, and more are just some of the things you can't control when taking candid shots especially. I have gotten into the habit of taking duplicate shots for this very reason. Also, I take pictures of whatever my focus is from as many angles as possible for the reason I shared at the beginning of this chapter. I had a client who contracted me to take photos. She was very specific about everything, including the pose and the angle she wanted me to take the shots from. Fortunately, the client was open to a little spontaneity, but only after I took the shots she wanted ... to the exact specifications she gave me. Well, thanks to the world of digital photography, I could show the client the photos that were created due to her specifications. Let's just say that we needed to choose a better angle to capture her beauty in the best light ... and I'm not talking about lightbulb light. We shifted gears.

We chose a new location and she allowed me to take lots of photos from several different angles. Boy, she was happy in the end.

There are times when I wish this was a photo book, but I knew right from the beginning that I would not be able to meet my publisher's deadline if I was limited to the number of photos I could have in the book. Anyway, I have a photo where some of my party guests are singing happy birthday to me in Italian. During this milestone birthday party, guests were put into groups and each group was asked to sing happy birthday in a different language. It was an amazing time. The picture I'm referencing is great. Hands are in the air, mouths are forming words - but not in a being caught mid-talking kind of way, the sheet music is in everyone's other hand, and you can tell that they are singing with passion and joy. It tells my birthday story, and every single time I look at it, I am back in the venue hearing the happy, out-of-tone voices. I can smell the amazing food, and feel how pretty I felt in my special outfit. I was being celebrated that night, and I could feel all the emotions and everything all over again. That's what a good photo with movement can do.

The best visual stories are easily digestible, memorable, and evocative. With the right photos, the impact and emotion generated from our stories

are magnified. I'm encouraging you to capture and choose photos with movement. Irrespective of industry, I will always err on the side that believes the photos with movement will best resonate with, and most effectively tell your story to your customers. When I'm capturing images to tell stories, I consider some of the following in addition to movement—I want to awaken the senses; stimulate emotion; please the eyes; create warmth; evoke nostalgia and instill a sense of concern.

In storytelling, a lack of movement can sometimes equal a lack of interest from the audience. I want to emphasize that people and things in motion tell our eyes to follow a certain direction and causes us to guess at what might come next. That's engagement. Keep things moving whenever possible, and where the story calls for it. While a great first impression is essential in capturing attention, closing in on the final, strongest image someone sees can make or break a visualization story. When you save the biggest moment to the very end, the audience is more likely to act on your content and call to action, and even share who you are with others. End with your takeaway. The final message should hit hard. It boosts the customer's power to remember the message you conveyed. Movement achieves this outcome well.

Camera Ready

Chapter 12:

Snapshot

―●―

*You don't make a photograph just with a camera.
You bring to the act of photography all the pictures
you have seen, the books you have read, the music
you have heard, and the people you have loved.*
—ANSEL ADAMS

It was a milestone birthday and I can remember deciding to hire a photographer. I have never hired a photographer. Why do that when I can take photos on my own? My tripod and timer never fail if I want to be in the photos. This was different. I had friends who were traveling from out of town and out of state to join me for this special occasion, so I wanted to have the freedom of being truly present and enjoying myself for my special celebration. I

thought I did everything right by asking a trusted friend for a recommendation.

The response was quick and the review was a glowing one. I had the opportunity to meet the photographer in advance and the meeting went well. I was excited and looked forward to being impressed by his work. It was time for the event, and just like I had requested, the photographer was at the venue before me to take photos of the décor and staff. As any good photojournalist would do, I expected to see and relive my story when all was said and done. I was enjoying myself but started to become skeptical when I noticed him talking much too long with some of my guests. He had already completely missed some pretty special shots, and that was cause enough to make me start watching him the remainder of the event. There was one time when I had to interrupt his conversation and ask him to take a specific photo. He did it gladly and then found his way back to talking. At that point, I decided to let it be and continue to enjoy the rest of my evening. I had spent quite a bit of money and I had friends and family to enjoy. Well, unlike my magazine cover story from earlier in the book, I was very disappointed when I received my photos. The photos did not tell my special story. The message was disjointed. Some of the photos were blurry and

there were very few of me. Now, what do you make of that? This person was expensive, and you should know that I paid him in full, and made the decision to not use him again. It's more important to me to maintain good relationships, especially with the friend who recommended him, but I learned from that experience.

So, what do I want you to glean from it? I want you to ask for examples of someone's work before you hire them. I want you to make provisions for the possibility that the person may not meet your expectations. To date, I have not had one unhappy client and I will strive to never have one. Yes, I know I may come across a client I can't please no matter what I do, but that day has not come, and I'm not looking forward to it.

So very often, the messy, disappointing, and most challenging parts of our lives are not only meant to grow us and teach us, they are meant for us to share. Sharing keeps us out of bondage to guilt and shame and opens the door for others to be blessed and relieved that they are not alone in what they may be going through. Because you have overcome an obstacle and are on the other side of a similar circumstance, there is hope for them to experience the same. How does this fit with all we've been talking about? Well, it gives you some insight

into who I am as a person. Transparency has a place in every single thing we do. Artistry and creativity are matters of self-expression and self-reflection. The soul and spirit play a big part. I don't know how you go into a visual storytelling project without love, passion, and transparency. I don't know how you lead a team without all of the same.

I've learned that you don't always get what you give, and that doesn't matter when *your* motivation is love and there is genuineness of spirit. If you don't have the love and passion for what you have been tasked to do, that's fine; just consider that the project can probably be done best and the outcome greater if done by someone who does … perhaps someone on your team or a professional you may choose to hire.

Here are a few other mistakes you'll want to avoid: try not to tell too much of the story. Remember, less is more, and people just don't have the attention span they used to. Make sure you do a great job casting your vision to your team and that you are collaborative in the planning process. This is the best way to get their buy-in and to keep them motivated. They will be looking to you at every step and stage of the process, so keep your team well-informed. No one likes to be blindsided and left-out of the communication loop. Reward

yourself if you're a one-person show, and reward the others if you have a committed and driven team. It matters a great deal when you recognize your accomplishments, especially the small ones along the way. It is important for people to feel valued and respected in the workplace. They are more likely to be happier and engaged when they are acknowledged, valued, and rewarded for their contributions to the company and its mission.

Lastly, try to keep distractions to a minimum. When you are in the flow of a shoot or a working or planning session but especially a photoshoot, the last thing you need is to be distracted by your phone, someone vying for your attention, or by some other pressing matter. Being fully present and engaged when you are in the creative process, in your creative space, while in a creative flow, will fare you much better. Trust me. Plus, your team is watching.

During a service project, a group of community volunteers was discussing a new opportunity to take on a leadership role within the community. This opportunity was very interesting and the skillset seemed to fit a woman most of us knew but who wasn't present at the time of the discussion. There was obvious resistance to the idea that this particular woman would be a viable candidate to take on a leadership role. When the question as to why not

was posed to the group, one woman said, "I know the name, but who is she, and what has she done for the community?" The sad thing is that we all knew the woman and we knew the job she held, but in all the many years she worked in the community, she had not put forth any effort to get connected in a meaningful way, and not to mention, hadn't been doing her job very well. I don't enjoy highlighting the negative but this is what it sounds like and looks like when people don't relate to you or your brand. This story reminds me of branding every time a new or young businessperson questions the importance of getting connected.

There really is no better time than the present to jump into the world of visual storytelling. There are an incredible amount of resources available to support your success. I've shared the main principles I consider when taking on the kind of project you've been tasked with, and once you have a solid plan laid out, everything else will begin to fall into place … just open your heart and jump.

A good visual story flows naturally.

Here's a snapshot of some of the basics:

- Make sure your company has a clear and well-communicated strategic mission, vision and direction for the future

- Have a tight plan—use a storyboard to keep shots/plan organized
- Shoot every day and shoot a lot—never leave home without your camera
- Stand in the background—become invisible when you shoot
- Content, composition, and creativity—consider a gift: creativity is the wrapping paper and bows you choose to use to make your gift appealing, composition is the box you've chosen as the best way for how your gift should be presented, and content is the gift itself, and of course you want it to be the very best
- Never stop being creative and taking risks—as a photographer, I also consider myself an artist
- Be consistent with your brand and messaging
- Your visuals need to be eye-catching and clearly express your brand's essence
- Movement—sequence and collection of shots is powerful messaging
- Always keep the audience in mind
- Take time to prepare—plan in advance, avoid frustration, avoid wasting time and money

- Be authentic and personable—build trust and make connections!
- Strive for strife—include conflict in your story
- Be educational—teach something, whether it's about the company or the market

Stories are told visually by using many different mediums, and, of course, what you choose will be most effective depending on your audience, the message you need to convey, and most definitely your skill level. Right now you have everything you need. Perhaps this book just confirms what you already know, and that's great. If not, and you still don't know where to begin, please don't lose heart. There are a ton of professionals who do, and I wouldn't hesitate to reach out. If there is anything that you would like me to expand upon then, please, by all means, let me know. Listed at the very end of the book is the way to connect with me.

Chapter 13:

Picture Your Profit

It's not enough to just own a camera. Everyone owns a camera. To be a photographer you must understand, appreciate and harness the power you hold!
—MARK DENMAN

We simply respond better to visual information than anything else. The human brain processes images 60,000 times faster than text and as I mentioned earlier, more than 90 percent of information transmitted to the brain is visual. The opportunity for visual storytelling to be the key method by which you define your company's culture—its philosophy, values, beliefs, and mission—explain products, services and so much more, exists at its best right now.

Asking for help and assistance does not reflect negatively on a wise business professional. I remember during the years I worked for a large financial services firm in New York, there was a businesswoman whom I always admired. It was amazing to me that she was responsible for so much, yet never missed a deadline and always seemed to be on top of her game. One night while we were both working late, I took advantage of the opportunity to ask her how she keeps it together and manages it all. She looked up with a fresh face—even after a fourteen-hour day, and responded, "I don't. Are you kidding me? I don't do it all. I surround myself with people who are smarter and more capable than me." I love that, and even though I got to hear those words so many years ago, it took me just about the same number of years before I would put them into practice myself. That, my friend, was the old me.

I'd like to believe that as we're at the end of the book, you are not only convinced about the need to have a visual narrative to tell your company's story, you are feeling pretty confident and excited about creating it with photos. If you're not, it sounds like you need a little more to get motivated and inspired. We talked about self-discipline and self-motivation pretty early on. I'd like to think that your motivation is your "why." Today, most people prefer

to work for a company whose mission and vision they believe in and have adopted as their own. They can see themselves as part of the company's story, as well as the value they add to the process and the bottom line. These same people also feel connected to those they work with and work for. Hopefully, this describes you and your "why." Okay, perhaps all you want to do is impress your boss and keep your job, and of course, that's okay too.

Picture Your Profit has everything to do with understanding that your company can expect to see an increase in revenue when they can see an increase in employee engagement. Telling your company's story through the use of photography (pictures) is a means to that end. Imagine for a moment if the company you enjoy working for treated its employees the same way they treat their customers. I mean the *same* way … imagine that! When a customer has a problem, the company goes to great lengths to solve it. When a customer needs extra attention, the company gives it to them. The company *never* makes the customer feel as if the customer is high maintenance. The company never lets a customer see and experience anything less the best from the company. To the company, the customer is always right. If you worked for a company like that—one that treats its employees like it treats its customers—

there's probably not much you wouldn't do for the company. You would most likely feel a tremendous sense of loyalty to the organization and its interests. Is this a realistic approach to elevating a company's human resources? You bet it is. Viable and doable.

Well, why shouldn't a company treat their employees with such a high degree of value and respect? Isn't it the employees, regardless of their position or title, who do the work to ensure the products and services are created, produced and delivered with excellence? In my experience, when a company goes above and beyond to express value and honor to its employees, the employees naturally respond with a high degree of engagement. It's not a mechanical thing—it's a natural thing. Don't you respond better to others when you are made to feel like you are welcome, included, and that what you bring to the table is valued and respected? I know I do. I go out of my way to make others feel this way, and I go out of my way to help businesses create a culture where this level of employee engagement can exist and thrive. We work together to create a culture where everyone happily embodies and stands behind the company brand.

Picture Your Profit also takes into account a company's need for a single, clearly stated, consistent and cohesive "operating system". In *What the Heck is*

EOS? A Complete Guide for Employees in Companies Running on EOS, authors Gino Wickman and Tom Bouwer share that companies are using EOS (the Entrepreneurial Operating System). They explain it like this: "That system is the way a company organizes all of its human energy. It's the way that the people in the organization meet, solve problems, plan, prioritize, follow processes, communicate, measure, structure, clarify roles, lead and manage." Having one operating system is critical to a company's ability to grow and to distinguish itself in their marketplace. The example in the book suggests that "if you have 50 people doing everything 50 different ways, the increased complexity leads to mass chaos. Even worse, people experience incredible confusion and frustration. Simply put, you can't build a great company on multiple operating systems - you must choose one." Further to that, you certainly won't be able to tell a great story. I've experienced many companies operating on more than one *Entrepreneurial Operating System*. All the company does is spin its wheels in the same place, with no forward movement and most times without even knowing it.

It's true what they say about a photo. It can speak volumes. I will add that it can, when incorporated into a company's initiatives, projects, and training

programs, significantly shift an entire culture for the better. It's worth in this process is so much more than a thousand words.

Humor me: let's do a practice exercise just to see where we are. Let's do some things that might create a spark and ignite some inspiration for a story. I sometimes just walk or take a run in a nearby park. You could also just simply sit still for an extended period. This works beautifully, and you may be surprised by what comes to you for inspiration in the stillness. I would have a small notepad available just to jot down the things that might inspire me. It could be anything like, colors, a book, a movie, music, a person walking by me, or anything else that evokes emotion or becomes thought-provoking. One powerful suggestion would be if there is currently a relationship you have that can use some mending. Perhaps an apology is warranted, or you simply need to express that you miss the person. You can make a sequence of photos to express these sentiments. The story could truly evoke wonderful memories, express love, and speak to the heart in a way that words simply can't.

I did this recently for a friend who I haven't seen in a while, and who I know happens to be healing from a broken heart. My sequence of photos intended to take her down memory lane—a happy trip where

she and I were having fun doing the things we enjoy. It created a lovely distraction for her and reminded her of how much she is loved. Man, do I love photos. They truly speak louder than words. Once you've got your inspiration, go shoot, and consider shooting a series of shots. You may want to give thought to the location, models, wardrobe, who knows? It all depends on the story you want to tell. You're only going to use six to eight shots or maybe even ten to tell a story about whatever it is that inspired you. You would be sure to take some wide shots to establish the location or environment your story will take place in; you would take some medium shots that would mostly include people or animals; then you would take your close-up shots for detail. These six to ten shots would be the sequence you would use for your visual story. Perhaps you might want to do a few of these with varying topics and in varying degrees of sophistication until you get inspired enough and gain confidence enough to work on the bigger project of telling the story of your business or the company you work for. I have no doubt you can do it. This is the beauty of digital photography. You can take as many shots as necessary to ensure the story is told the way you want it.

There was much we didn't talk about like the value of b-roll shots, the law of thirds, and the

importance of editing. This book wasn't intended as a complete resource guide. It's to inspire and provide just enough insight to get your juices flowing. I am hopeful that you'll move forward with confidence, and that you know you are not alone. Technology changes as soon as we get comfortable with it. Sometimes people will throw out terms and concepts that you're not familiar with. That's the wonderful thing about Google. You can look up anything and it will more than likely be there.

You too can *Picture Your Profit*. This book is also intended to share my insight and the expertise I have to transform a team, a culture, and a company in a way that lays a foundation for businesses to achieve great things … with photos and people. I help companies understand where the responsibility lies in carrying the branding message forward.

If you need help and growth, I would love for you to reach out. In the meantime, practice, practice, practice and have faith and trust. Please, don't leave out the fun. This is an exciting time in the information age, and the tools and resources are ours to take advantage of. For what this book was meant to do, I believe I've done a good job in giving you the principles, the concepts, the tips and the most important things that you should set your mind, your energy, and your heart to. I've also

extended some love. I can only hope that you will pay it forward by telling a great visual story, elevating the people who contribute to it.

Acknowledgments

I want to thank God for loving me the way He does, and for yet another opportunity to write and to express love to others through my work.

This book could not have been completed if it was not for Craig Reid, who covered for me the whole time I was serving my clients and writing this book.

I want to acknowledge my dear friends, Maria Segarra and Tracy Skinner, who are a constant source of love and encouragement.

I want to give a huge shout out and thank you to Beverly Mattox of 360 Digital Media. Her friendship, love, and support have been ever-present during all of my big endeavors.

I want to acknowledge Joyce Beverly of Fayette Woman Magazine. Her generosity and humility in

how and what she gives, are absolutely beautiful expressions of love.

I want to thank Judy Suitor for reaching out and pouring into me. She is a wonderful example of genuine mentorship.

I want to acknowledge the amazing humans who I worked most closely with at the Author Training Academy.

Dr. Angela Lauria of the Author Incubator, who seems to be with me even when we're not together, has been nothing short of amazing and incredibly supportive during my journey to becoming an author, and the completion of this second book. Her coaching, love, words of wisdom, and business acumen have been just what I needed to keep things moving in the right direction.

Cheyenne Giesecke, Tami Stackelhouse of FLOW House (I love that), Moriah Howell, Ora North, and Trevor McCray. Thank you and blessings to each of you for every single thing you do (and have done) … small and large … to support and elevate me.

I want to take this opportunity to acknowledge the inspiration my grandbabies, Kye Alexander and Leigh Devonne, provide to me each and every day. Their sweet little faces, those beautiful eyes, and those little hands that touch my face are an extension

and expression of God's love that surrounds me and follows me everywhere that I go.

Thank you to David Hancock and the Morgan James Publishing team for helping me bring this book to print.

Thank You

Thank you for reading *Picture your Profit*. I hope you have found it to be a useful resource for your visual storytelling journey.

The opportunity to express oneself creatively is available to all. If I can be of service to you and your team, please reach out to me directly at pam@reidcreation.com.

I look forward to hearing from you, and most importantly, I look forward to seeing your visual expressions across the media channels.

You can follow me on Instagram @reidcreation and visit me at www.reidcreation.com

About the Author

Pam Reid is Founder and CEO of FLOW Consulting Group, and Founder and Creative Director of ReidCreation. Pam is a freelance photographer, business consultant and coach, trainer, and professional speaker who believes that photography is an act of love, self-reflection and self-expression.

Pam has her degree in Business Administration, loves to travel, and very much enjoys working with individuals, groups, and business clients to tell their story and to elevate the morale and engagement levels of their teams. Pam was telling stories with photographs long before visual storytelling was ever

a thing, and her ability to use photography to elevate a brand and a team has become a thing of its own.

www.ingramcontent.com/pod-product-compliance
Lightning Source LLC
Chambersburg PA
CBHW020914180526
45163CB00007B/2730